KINGSBURY
THROUGH TIME
Geoffrey Hewlett

with best wishes

Geoffrey Hewlett

AMBERLEY PUBLISHING

To Susan, Benjamin and Robert

First published 2010

Amberley Publishing
Cirencester Road, Chalford,
Stroud, Gloucestershire GL6 8PE

www.amberley-books.com

Copyright © Geoffrey Hewlett, 2010

The right of Geoffrey Hewlett to be identified as the
Author of this work has been asserted in accordance
with the Copyrights, Designs and Patents Act 1988.

ISBN 978-1-4456-0039-0

British Library Cataloguing in Publication Data.
A catalogue record for this book is available from
the British Library.

Typeset in 9.5pt on 12pt Celeste.
Typesetting by Amberley Publishing.
Printed in the UK.

Introduction

Today Kingsbury forms part of the London Borough of Brent. The suburban development of the area between 1924 and 1938 merged its scattered but distinct villages, farms and country retreats into a single suburban area, thus completely changing its character. The name of Kingsbury was first recorded a thousand years ago. Its fourteenth-century population of twenty-three men, plus their wives and children, had doubled to reach 200 by 1801 and only stood at 821 by 1911.

The Black Death of 1349-50 certainly reduced the numbers, and many survivors chose to move away. The loss of residents at what was the old centre of Kingsbury down at Blackbird Hill was made good by a small increase in population at Kingsbury Green and The Hyde. It was at these two locations that settlements were identified in maps of 1597, and this was where Victorian expansion took place from at least 1850, thus spurring the controversy about a new church (Holy Innocents) being provided where Kingsbury residents were actually living.

Kingsbury impressed visiting outsiders with its rural appearance even as late as the early 1920s. Walkers and cyclists came to the Plough Inn to be out in the country and to be amused by a group of Frenchmen and three performing bears or by an organ grinder and velvet-clad monkey. Kingsbury also had a polo club where the Duke of Westminster played.

What triggered Kingsbury's twentieth-century transformation was the decision to site the London Aerodrome at Hendon, and the implications this had for local industry when war broke out in 1914. Kingsbury found itself at the centre of aircraft and munitions production. Agricultural land was sold for the building of factories and therefore acquired an industrial land value. With one exception, De Havilland Road, such land as Kingsbury Green and The Hyde has remained in commercial use to this day. Of the local airfields, only Stag Lane survived the First World War, but not for long.

New housing was at first linked to wartime needs with the building of Roe Green Garden Village. Kingsbury Urban District Council further met its housing needs with a new estate at High Meadow Crescent, which was designed by James Webb and built in 1924. The principal roads, such as Blackbird Hill, Church Lane and Kingsbury Road, were widened and straightened in the early 1920s for the British Empire Exhibition, held at Wembley Park in 1924-25, which attracted many builders and potential homeowners to the area.

Improved access was a major issue, and the Metropolitan line extension to Stanmore sought to address it in 1932. With the road and rail infrastructure in place, the area was ripe for development. How this occurred and the impact this has had is dealt with in *Kingsbury Through Time*, which serves to remind us how quickly things can change.

A Note on the Author

Geoffrey Hewlett has lived all but two years of his life in the suburbs of North West London. He is happily married and living in Stanmore. Educated in Kingsbury and at South Bank, he is a former chairman of the Wembley History Society and has just retired from forty years' service as a town planner in local government. He is an expert in the history of Kingsbury and Wembley, on which he has written and lectured widely. This publication draws on much of the author's own collection of photographs as well as his hitherto unpublished interviews of residents, some of whom recall a Kingsbury of 1890-1905.

The Original Kingsbury

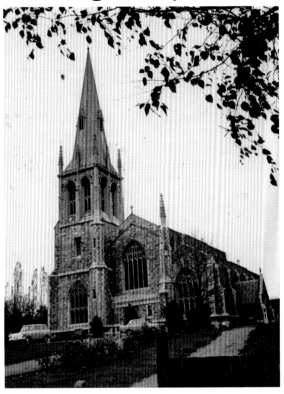

New St Andrew's Church (I)/ Blackbird Hill (I)

The name 'Kingsbury', or 'Cyngesbyrig', means 'king's stronghold'. It was recorded in 1003/04 and in the *Domesday Book* of 1086.

Blackbird Hill was once part of a pre-Roman trackway that rose steeply from the River Brent (where Jon Chalkhill's sixteenth-century mill pond used to flood the road) to a cluster of farms, houses and a church, which together comprised the old medieval village of Kingsbury. Blackbird Farm existed on both sides of Old Church Lane, at its junction with Blackbird Hill. On the south side – the lower yard, seen below in 1897 – were cowsheds and two farm cottages.

Right is the new St Andrew's Church, moved here from Central London in the 1930s.

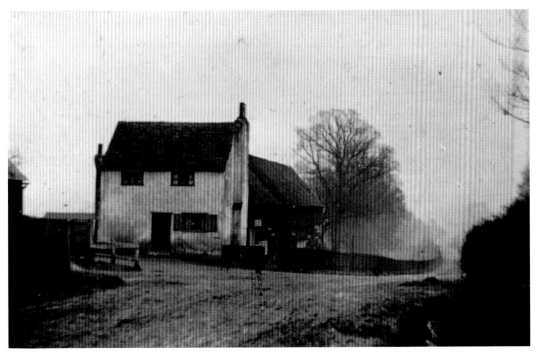

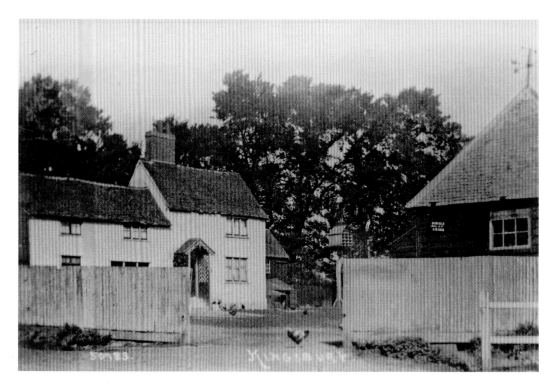

Blackbird Farmhouse

The main farmhouse stood on the north side of the junction. At its entrance was a large pond and by a square store shed, the granary. The painting of the farmhouse is dated '1922'. The grassy fields were mainly for cattle, although there used to be a small wheat field at the top of Blackbird Hill.

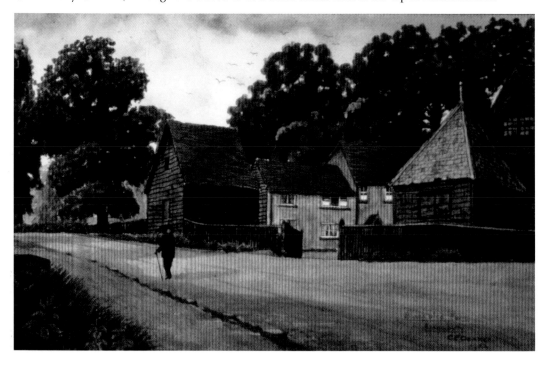

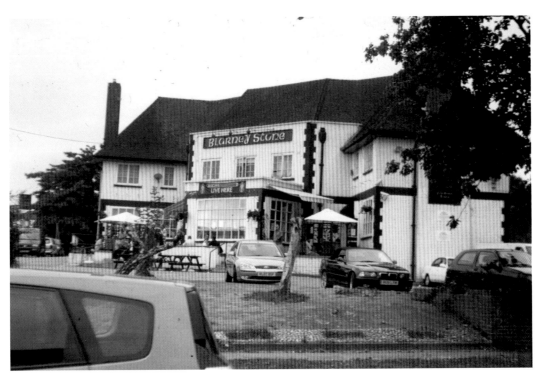

Blackbird Hill (II)

The lower yard was redeveloped for shops in around 1936 and the upper yard – the principal farmhouse – was demolished in 1955 and replaced by the Blackbirds Public House in 1958-59. Recently renamed the Blarney Stone, as seen here, it is currently boarded up, awaiting demolition and redevelopment.

From Blackbird Farm, Old Church Lane passed the cemetery of St Andrew's Church. The churchyard immediately around the church must have been greatly overused; it was extended in 1900.

Old Church Lane

Although reconstructed during the housing development of the 1920s, Old Church Lane retains something of its rural appearance even now, enhanced by the mock-Tudor style of the housing. The scenes here predate the First World War.

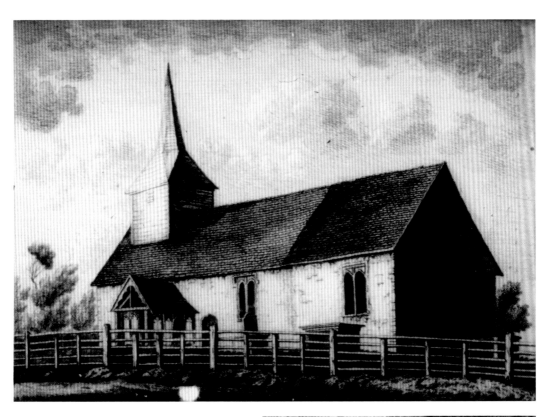

St Andrew's Old Church (I)

The church in 1807, its porch in 1816.
For much of its history, Kingsbury
parish was a poor, isolated, relatively
underpopulated area, and St Andrew's
suffered from periods of neglect and
decay. Vicars held other livings to
which, as in the parishes of Harrow
and Willesden, they gave greater
priority. In 1822-24, the curate was
Francis Close and it was he who
established a school at Kingsbury
(see pages 34-5). The old church
incorporates Roman tiles, hypocaust
flues and a medieval coffin lid. It is
now thought to date from the end of
the eleventh century.

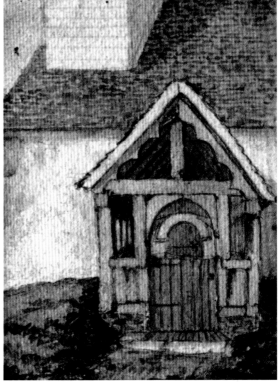

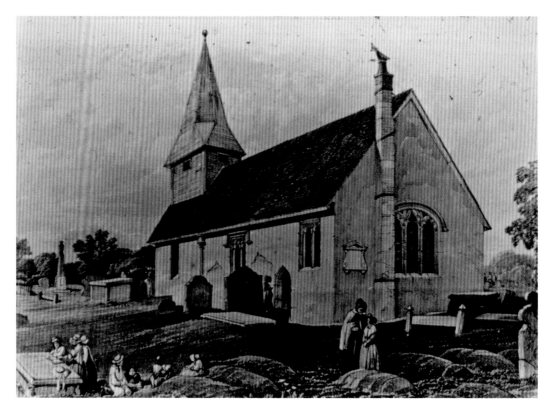

St Andrew's Old Church (II)

Major restoration was carried out in 1840. The main south entrance was bricked up, its old wooden porch was demolished, and the rood screen was removed. The Norman font was deposited in a nearby pond. Below is the church in around 1880. The restoration of 1870 saw the chancel walls refaced and the wooden belfry and spire replaced by a similar structure. But when Revd Lambart Edwards became vicar in 1883, the structure still needed urgent repair.

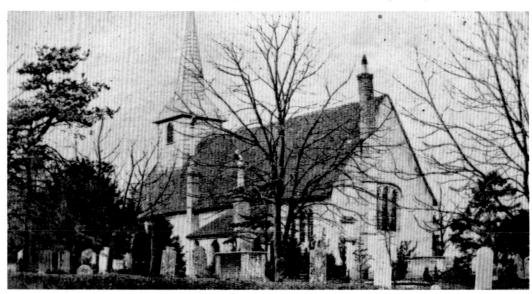

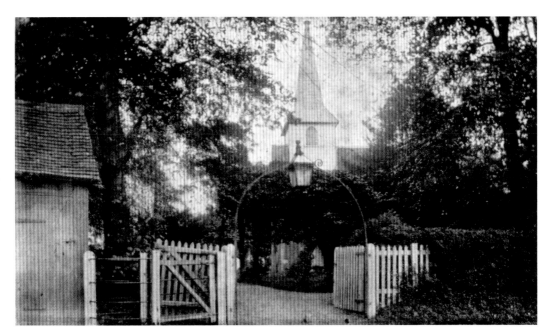

St Andrew's Old Church (III)

The old church was threatened by
the opening of Holy Innocents on
Kingsbury Road and by a closing
order dated 6 June 1884. Residents
wishing to retain the old church
obtained another order, dated 9
July 1885, by which it became the
Parish Church of Neasden-cum-
Kingsbury. The third restoration of
1888 included restoring the south
door and constructing a new vestry.
The church is pictured in 1904 and
1981. The lych gate has since been
demolished.

St Andrew's Old Church (IV)
Two artists' impressions of Kingsbury's rural tranquillity just before the coming of suburbia in the 1920s. The old church was finally declared redundant on 9 March 1977 and has been in the care of the Churches Conservation Trust since 7 October 2003. There are currently proposals to use it as a heritage and cultural centre.

St Andrew's Church (II)

The old church was too small for Kingsbury's increased population in the 1920s and 1930s. As larger accommodation was needed, the Bishop of London decided to try moving a redundant city church. In Kingsbury's case, it was decided to move the famous church of St Andrew's at Wells Street, near Oxford Circus. Above is St Andrew's in its original setting, below is the church in its new location in 1979.

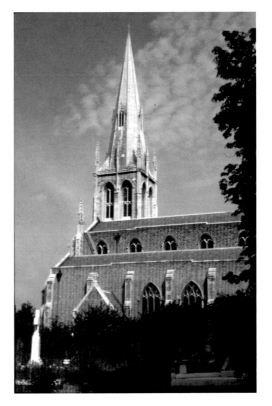

13

St Andrew's Church (III)

The church being rebuilt in Kingsbury in 1933, and the church again in 1937 (bottom left). The church was designed by S. W. Dawkes and was originally built in 1845-7. It became famous for its music as well as for its design, but the residential quarter around the church became shops, offices and warehouses and by 1914, congregations were much reduced in number. The last evensong was sung on Easter Day 1931. The building was dismantled in 1932/3 and transported stone by stone to Kingsbury, where it was re-erected in 1933/4.

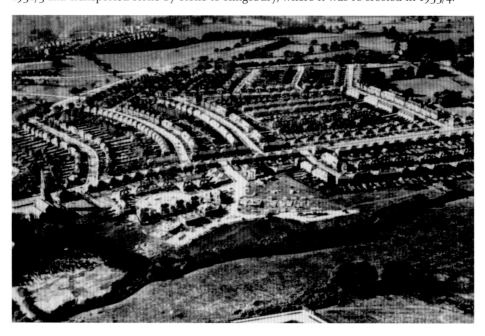

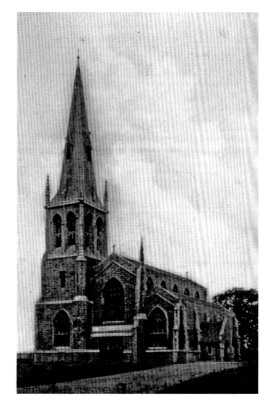

St Andrew's Church (IV)

Above, the exterior in 1935. Benjamin Webb, the co-founder of the Cambridge Camden Society and editor of *The Ecclesiologist*, was the vicar of St Andrew's in 1862-85 and did his best to find high-quality internal fitments. Major architects of the day contributed. Of note is the sumptuous reredos in alabaster and Caen stone, which was superbly carved by James Redfern.

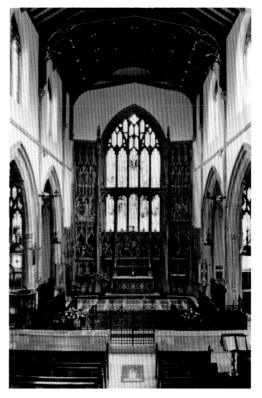

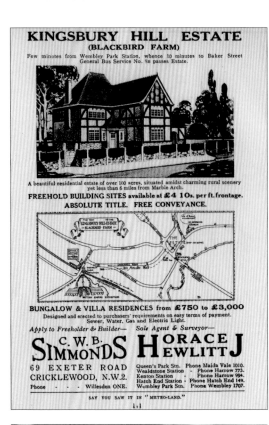

Old St Andrews Mansions

Today the main road follows Tudor Gardens, for which land was provided by Kingsbury Estates in 1927. Previously, through-traffic followed Old Church Lane. Housing here was encouraged by the Metroland estate across the way at Chalkhill, where building began in 1920. The 1930s housing at Old St Andrews Mansions, Church Walk is by E. G. Trobridge (see also pages 36-7, 64-6), but most of Old Church Lane on the Blackbird Farm estate at Kingsbury Hill was built by C. W. B. Simmonds in 1923-29. He had just completed the Mapesbury estate at Cricklewood and his Kingsbury houses were being advertised in the 1924 edition of *Metro-land.*

Fryent

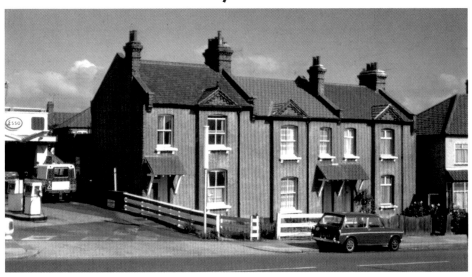

Fryent Farm Cottages

Freren ('brothers') or Fryent Manor was an estate belonging to the Knights Hospitallers, until the religious order was suppressed in 1540. Later curates of St Andrew's Church complained that there was nowhere for them to live, so by 1650 they were leasing a room in the farmhouse attic; the farmhouse became known as the Kingsbury Parsonage House, or Friant. Below are the older Fryent Farm Cottages in Church Lane in 1920 – above is the site in 1979. The Ecclesiastical Commissioners sold most of the land around Fryent Farm between 1928 and 1931. The farmhouse was demolished in 1955 and is now the site of Merley Court. Henry Smith, the huntsman to Baroness Rothschild and the farmer at Fryent, was killed in an accident in July 1899. Lavender Avenue was named after Charles Lavender (1827-1927), the Fryent farmer and county councillor.

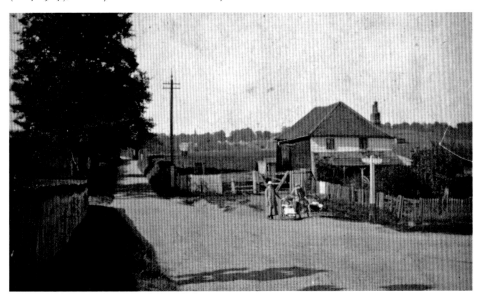

Wood Lane

The year is 1932 and cattle are being driven along Wood Lane while the countryside is lost to suburban housing. Some old rights of way survive amid new housing layouts. One field path can still be recognised, leading to 160-214 Church Lane, set back from the main road. Builders transformed Fryent's countryside. R. C. Campbell and W. J. Jennings, for example, obtained planning permits to develop the Kingsbury Park and Wood Lane Estates in 1928 and 1931.

A. E. BURROWS BUILDER CONTR

ESTATE OFFICE: 156 CHURCH LANE, K

THE

FREEHOLD PROPOSITION

IN THE DISTRICT

· . ·

PRICE FREEHOLD

£795—£875

REASONABLE DEPOSIT

LEASEHOLD £670

· ·

DALE 6131.

18

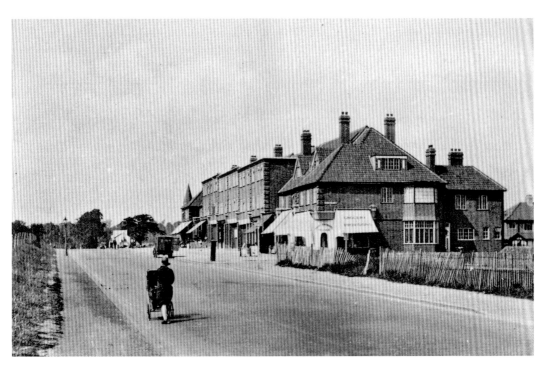

Church Lane
Shops on Church Lane in around 1930, and those on the same site today.

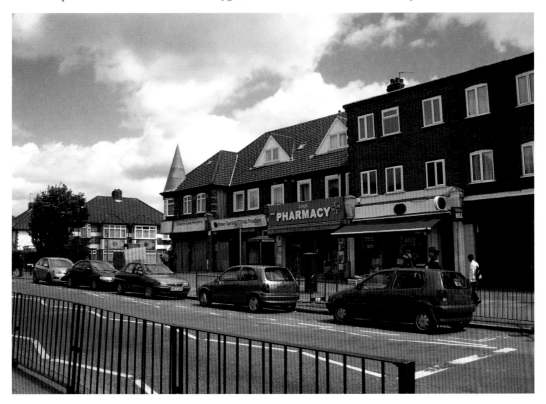

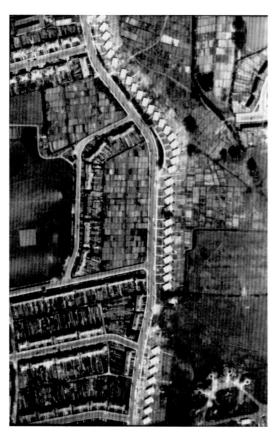

Around Kingsbury Green
In the summers of 1946 and 1947, the Ministry of Defence gathered information on property damage. This aerial photograph, taken in April 1947, shows Townsend Lane (north-south) with prefabs, allotments and a gun emplacement in Silver Jubilee Park. Thirty-six sustainable housing units, named Carter Close, were built in 2004-05 on the Elthorne Way allotments.

Below, Church Lane leading to Kingsbury Green in 1897. The road was once typical of the local lanes, with hedges and fields on both sides.

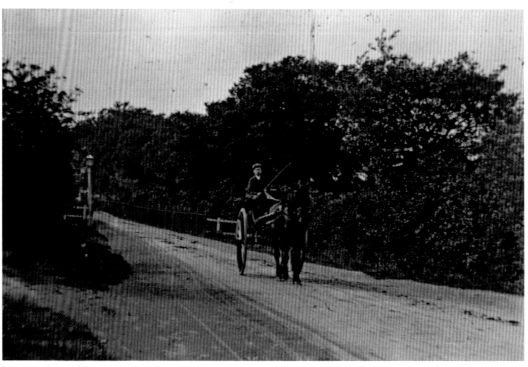

Kingsbury Green

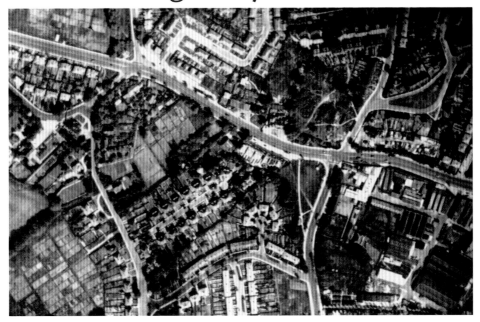

Kingsbury Green (I)

The old Kingsbury settlement was severely hit by the Black Death; the demise of at least thirteen people was reported at Kingsbury Manor Court in 1350. Complaints at court for not maintaining or repairing dilapidated houses were made throughout the next two centuries. In due course, Kingsbury recovered, but in a totally changed form. The original settlement had shrunk from a village to a church with one or two farms, while a 'new' village had appeared one mile to the north, at Kingsbury Green. It was here that new houses were built in the fifteenth and sixteenth centuries. Above, an MoD aerial view from May 1946, with Church Lane north-south to the right and Slough Lane and Salmon Street to the left.

Below is Ash Tree Dell – further north – in 1931.

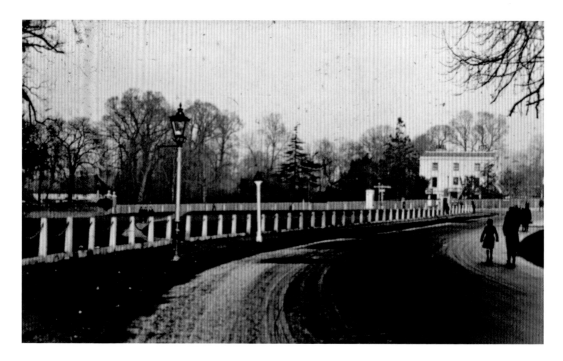

Kingsbury Green (II)

Above is the green as it was in 1930 with the Plough away to the left and White Lodge to the far right. White Lodge was the offices of Kingsbury Council from 1929-34. It was demolished before the war and was replaced in 1952 by Mead Court – sixty-one flats in one four-storey block and five three-storey blocks. During excavation work, Roman remains and some large pieces of medieval pottery were unearthed. Below is Mead Court as it is today.

Buck Lane

At the junction with Kingsbury Road. On the right of the junction is the Council yard, the top half of which was later used for war damage repairs. The ground was owned by the Kingsbury Charities Trust, so that when the plot was first redeveloped in 1953-54, the estate cul-de-sac – Bowater Close – was named after Richard Bowater of Chalkhill House, one of the Trust's eighteenth-century founders. Below is Buck Lane (and Church Lane) as it is today, complete with a traffic barrier.

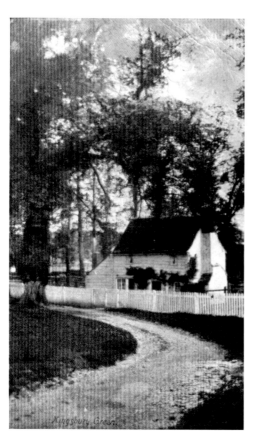

Ivy Cottage and Eden Lodge

These two buildings lie on the south-west side of the green. This is how they were in 1897. In around 1900, part of Ivy Cottage became a sweet shop. The timber-framed cottages were removed as part of a slum clearance program and public lavatories, since removed, were built here. Eden Lodge (below, centre) was an attractive early Victorian villa with a large front lawn adorned with chestnut trees. Shops were built by Hendry and Schooling in the mid 1930s. It was used for worship by the local Jewish community from 1942 and was demolished to make way for the present Kingsbury District Synagogue by David Stern & Partners in 1966-8.

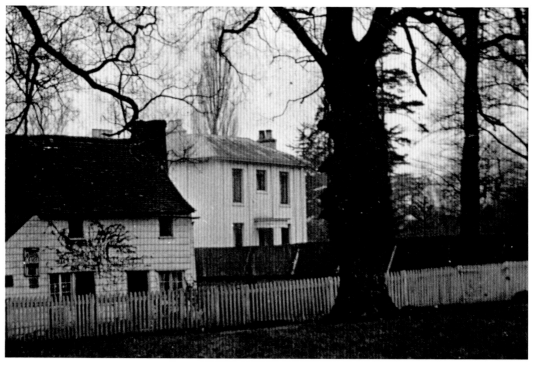

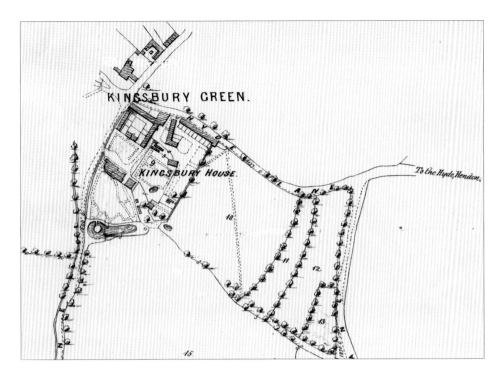

Kingsbury House

An estate layout dated 28 February 1906 that accompanied the deeds for Kingsbury House. Kingsbury House and its outbuildings, which stood on the site of a medieval tenement on the eastern side of the green, are now part of the Kingsbury Trading Estate and the Dairy Crest milk depot. Kingsbury House was a large three-storey Georgian villa set in substantial grounds. It was used commercially after 1916 and demolished in 1930.

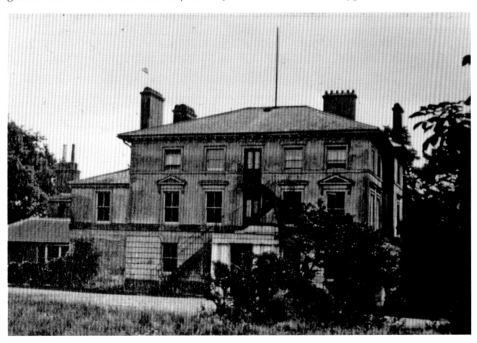

Stud Farm

Remnants of the outbuildings in 1974. The site is now a Theoco motor vehicle garage. The Stud Farm was built by William Burton in around 1883. A. G. Vanderbilt kept horses here, but the farm ceased business when Burton and Vanderbilt died in 1914-15. The Barningham brothers bought the grounds in 1916. Operating as the Kingsbury Aviation Co. they turned the site into an aerodrome and during 1918 they built 150 DH6s and thirty Sopwith Snipes. Thereafter, the company became the Kingsbury Engineering Co. The 1926 aerial photograph shows the airfield, Kingsbury Road, and, top right, High Meadow Crescent – Kingsbury's first council estate.

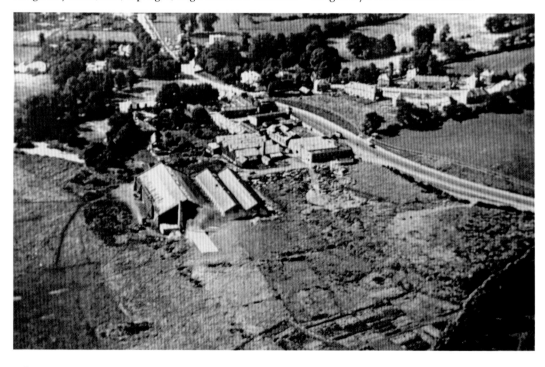

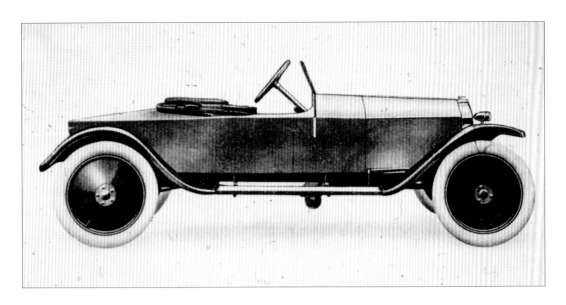

The Kingsbury Junior / The Kingsbury Motor Scooter

In 1919, the Kingsbury Engineering Company, with Warwick Wright as a member of the board, designed a popular motor scooter, called 'the Kingsbury'. The specimen below is in a private museum in Assisi. Its price was originally £39. This was followed by the production of the Kingsbury Junior two-seater car, although this did not last very long. It was exhibited in White City in 1920, at stand no. 429, and was priced £295. The Kingsbury Engineering Co. was finally dissolved on 21 June 1921. (*Photo below by Georges Jansoone*)

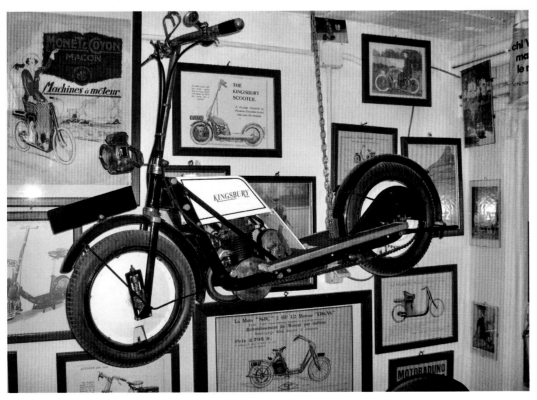

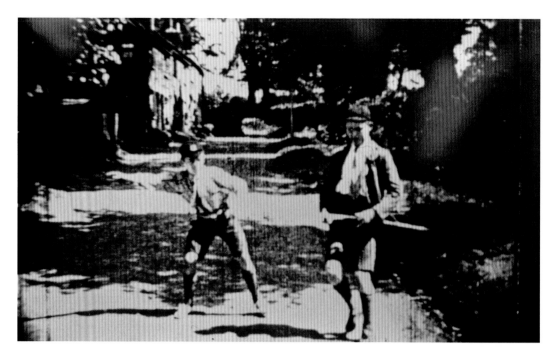

Walter Forde's Film Studio

After the aerodrome closed, Walter Forde (1896-1975) used part of the premises as a film studio. Moving into Kingsbury in the early 1920s, Forde began directing and starring in silent British slapstick shorts, many filmed around Kingsbury. This still from *Walter Wants Work*, filmed in Kingsbury in 1922, shows Buck Lane near its junction with Kingsbury Road. He went to Hollywood in 1923.

The works remained empty until August 1923 when, as seen below, they were occupied by Vanden Plas (England) 1923 Ltd.

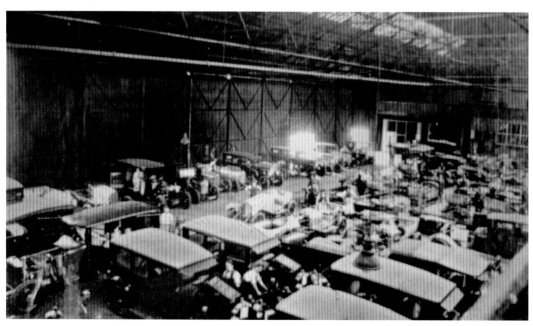

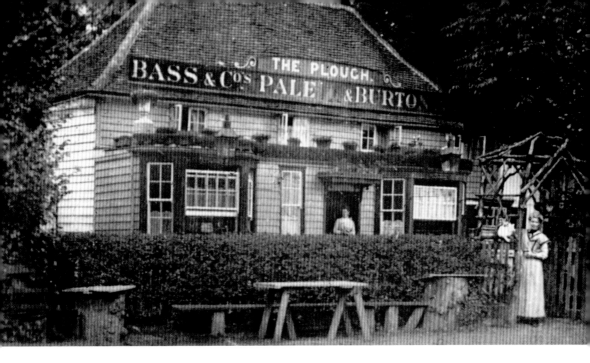

The Plough (I)

The Plough at Kingsbury Green was on the site of a medieval tenement, but it clearly predates 1748, which was when it was first licensed. After its demolition in 1931, it was replaced by a large two-storey brick pub with attic rooms. The pub became the Great Eastern in around 2000 and has just undergone a further refit and change of name, reopening in May 2009 as the Jewel.

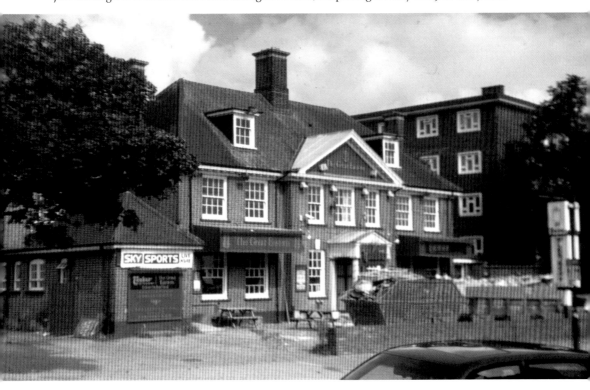

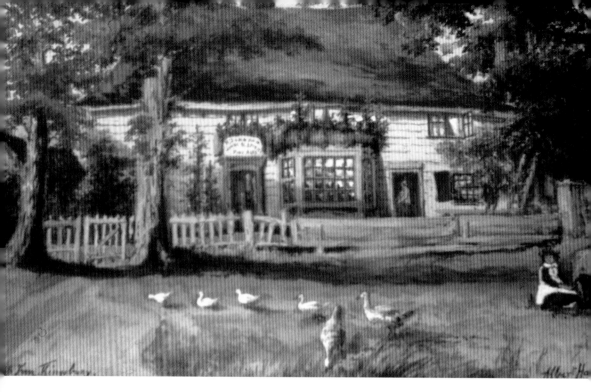

The Plough (II)

Above is the Plough, which was painted in 1891 by Albert Hardy. Henry Johnson was the licensee from 1890-1906; he was succeeded by Dick Giles. Johnson also ran the Red Lion in The Hyde from 1908 until his death in 1927. His daughter, Dora, was married in 1897 and the wedding party is here photographed outside the Plough. Johnson is on the far left at the rear. Kingsbury Road crosses the picture left to right.

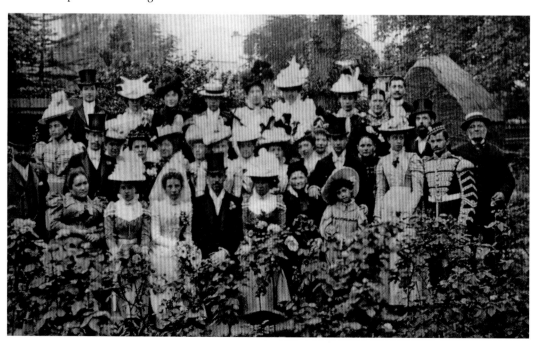

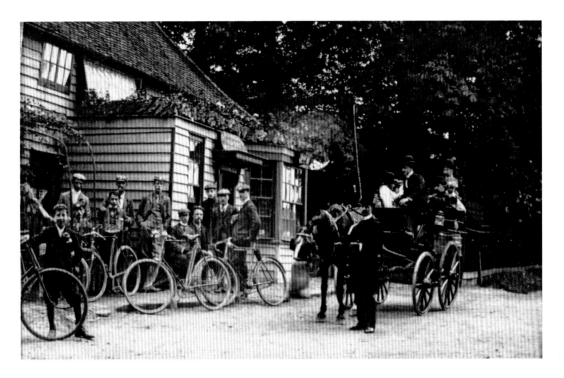

The Plough (III)

St. John's Wood Cycling Club at the Plough in around 1900. Kingsbury once attracted many walkers and cyclists, who would visit Kingsbury on day trips. The Plough Inn, with its attractive gardens, was once the headquarters of thirteen cycling clubs.

Below, Pipers Green, on the south side of Kingsbury Road, awaits its 1950 development.

Suncrete House

This was a concrete house apparently given as a prize by the *Sunday Chronicle*. It was designed by the Architect Reginald Blomfield in 1926. T. W. Stephenson was the owner in August 1927 and it was still occupied in 1930. On the site of the house is Suncrete Parade, built in 1934 and now part of the general parade of shops at Kingsbury Green, here photographed in 1950.

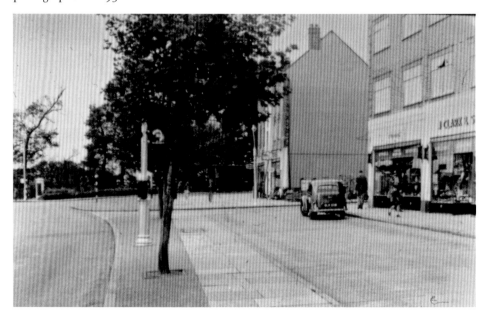

Pipers Green

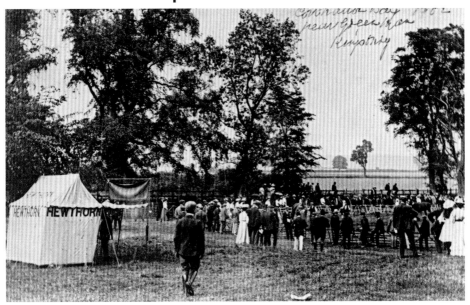

Work and Play

West of Kingsbury Green along Kingsbury Road lies the Pipers Green estate, which replaced St Mary's Lodge and its adjacent paddock between 1948 and 1950. This is now the only recognition of a hamlet that, until a century ago, had its own identity. Its name, which may have been derived from John Lyon, a local piper, was mentioned in 1422, although Pipers Farm does not seem to have appeared in Old Kenton Lane until the seventeenth century. Above, the Coronation Games of 1902, near the Green Man public house. Below, the hay harvest at Pipers Green in 1930, photographed by local historian Stanley Holliday.

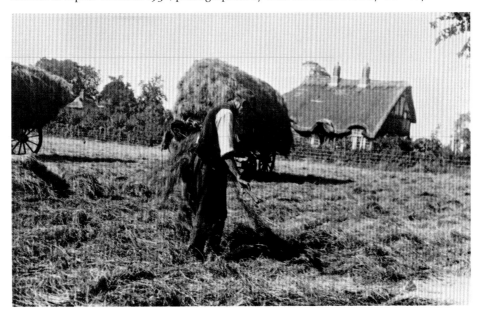

The Old School House (I)

The old school on the corner of Kingsbury Road and Roe Green was a white single-storey building with a slate roof. It was formerly the national school for the area under the aegis of St Andrew's Church; it was established in 1823 when Revd Francis Close was curate. When the local authority became responsible for education, the school house was converted into a residence. Alfred Dumain, a policeman, lived there with his wife in the 1890s.

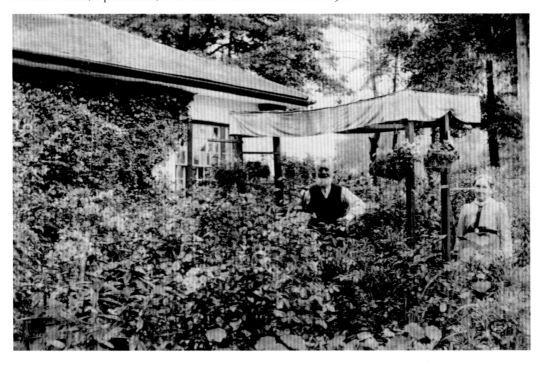

The Old School House (II)

By 1922, Laura Fox was living at the old school selling sweets and tobacco. The reconstruction of Kingsbury Road took over part of her garden. The property became affectionately known as 'Fox's Corner' and she remained there until the 1930s. It is now the site of the Lucy Margaret Cloke memorial garden, which the council maintains near the bus stop in Roe Green. The garden was paid for by the developer, George Cloke, as a memorial to his mother when he sold the land for the park. The photograph below shows the construction of Kingsbury Road in the 1920s, bypassing Old Kenton Lane.

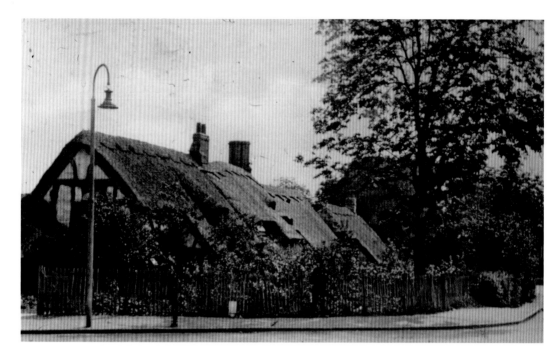

Hayland, Kingsbury Road (I)

The photograph above was taken in the 1930s, the second in 1939. Hayland was the first of Kingsbury's thatched houses, designed by the local architect Ernest George Trobridge. He built it for his father-in-law, Lawrence Pulsford, in 1921-2, after the Ministry of Health had given its approval to his patented Compressed Green Elmwood form of construction in 1919. Trobridge was then resident at Haydon House in Roe Green, but moved to Hayland himself and lived there till his death in 1942.

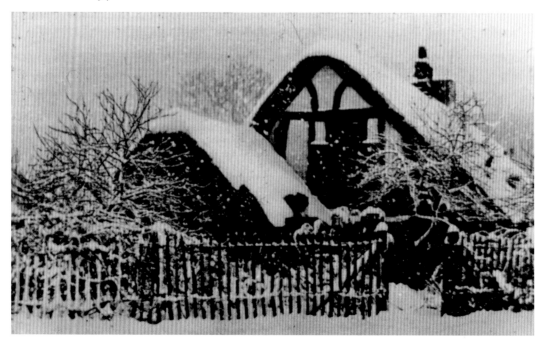

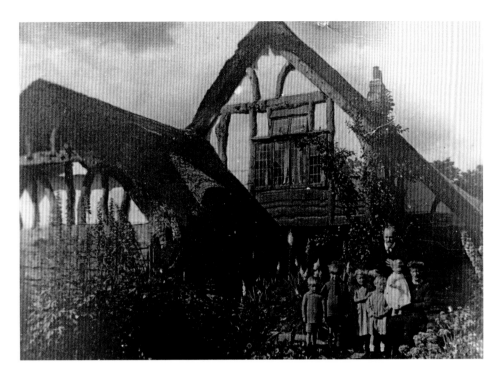

Hayland, Kingsbury Road (II) / The Green Man (I)

Trobridge at home with his family. His estates of thatched cottages were intended to provide good cheap housing quickly after the war. He employed disabled ex-servicemen under a scheme agreed with the Ministry of Labour in 1920. Intended purchasers financed the house construction along co-partnership lines. His first estate was the Ferndene estate at Pipers Green.

Below is the nearby Green Man public house in 1930.

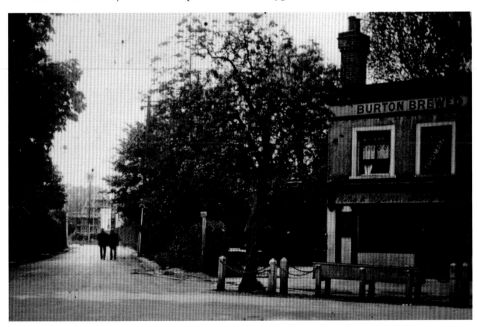

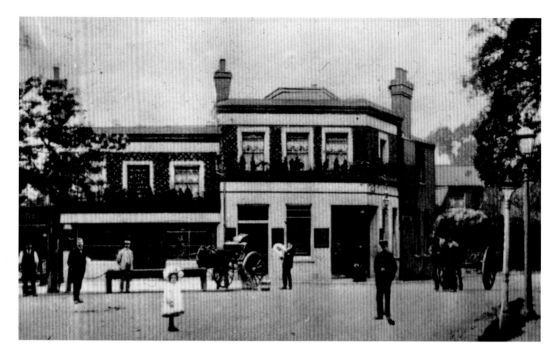

The Green Man (II)

The Green Man before 1914 and as it is today. It began life in the 1840s as a beer house. The premises were then a rather plain two-storey building and a pleasant tea garden. The present building of 1936/37 (architect A. E. Sewell) is a large two-storey red brick structure with a steeply pitched and hipped roof with dormer windows and tall chimney stacks. A banqueting suite at the rear has recently been demolished and replaced by housing that respects both the designs of the public house and Sunningdale Gardens, an estate of houses and flats built next door in 1963.

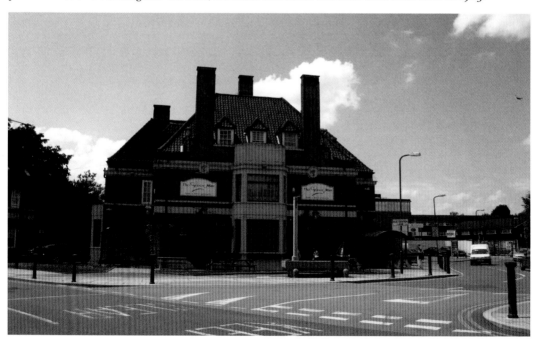

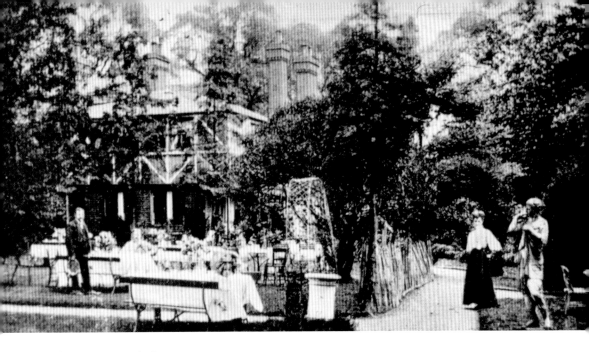

The Green Man (III)

Above are the tea gardens at the Green Man in 1910.

 Below is Kingsbury School's first class. Kenton Lane Junior Mixed and Infants School was built by Middlesex County Council in 1922, but the main brick building was not built until the school opened as a senior school in 1928. In 1948, the senior school – Kenton Lane Council School, renamed Kingsbury Green School – was opened for juniors and infants.

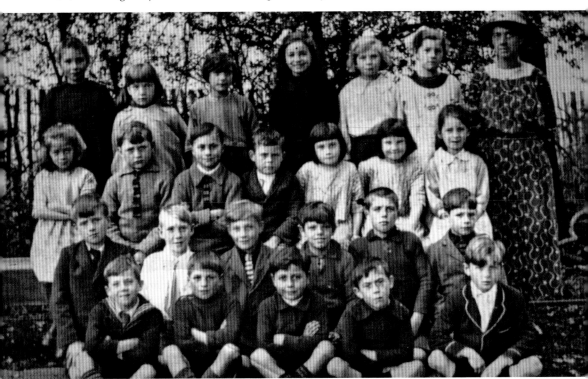

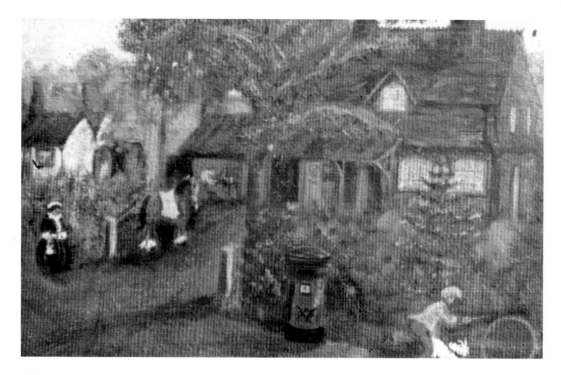

Old Kenton Lane Smithy

Above, the smithy as it was in 1920, painted by Win Upton. Below, as it is now. By 1871 the neighbouring terrace of houses was known as Pipers Green Cottages. For at least seventy years from 1861, the local smithy adjoining the terrace was occupied by Charles Jones and his family. His kinsman, Edwin Jones, was still the farrier there in 1928. The smithy stood next to West View and the building appears to have survived until the late '70s.

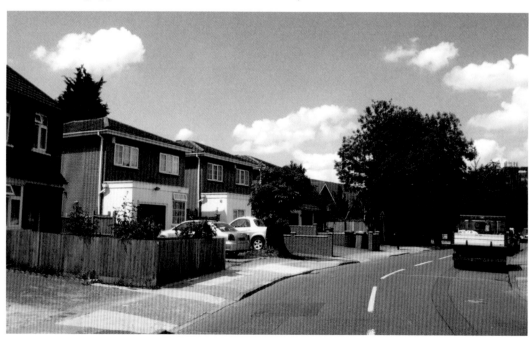

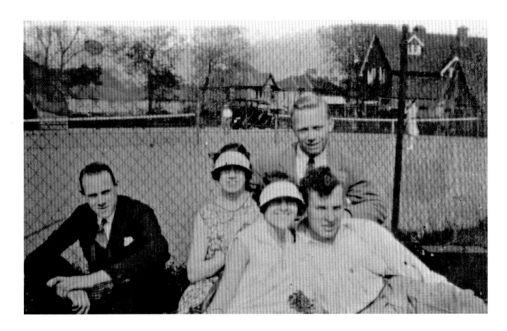

West View / Big Bush Farm

The seventeenth-century farmhouse West View is just visible across the tennis courts. It was demolished in the 1970s to make way for 27-29 Old Kenton Lane. Valley Villas – farm labourers' cottages built in 1900 – survive on the return frontage. The London Transport Sports Ground was opened by the London General Omnibus Co. in 1927 when the 183 bus route began along Kingsbury Road. It was in use until 1987. Vincent & Gorbing were the architects of the 108 housing units built on the site in 1996-8.

Big Bush Farm, like Salmon Street, was medieval in origin. The farm is seen here in 1924. Its last occupants left in around 1936 and the premises were demolished. In 1944, a V-1 rocket dropped on the farm, killing a thatcher. The access now provides an entrance to Fryent Country Park.

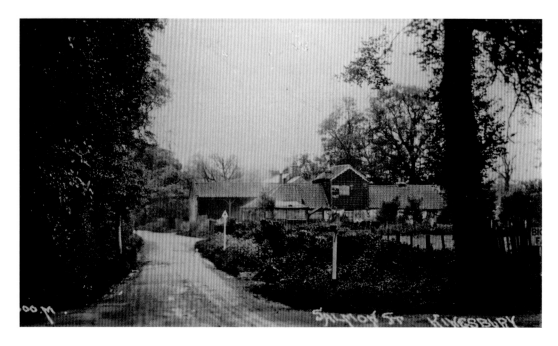

Little Bush Farm / Hill Farm

Nineteenth-century Little Bush Farm, above, was just south of the Slough Lane/Salmon Street junction, and was medieval in origin. In 1915 it was occupied by polo-pony dealer George Withers, but by the 1930s it had closed. It was bombed in the war and later demolished. Most of the Fryent Country Park farmland was sold for public open space by All Souls College in 1938. Hill Farm, on the hilltop in an April 1947 aerial view, was the most important of the farms. The farmhouse was mentioned as early as 1331. In the 1890s, the farmer kept horses and, later, polo ponies. By 1936, a Premier School of Equitation had been established. The farmhouse was demolished in around 1960 and replaced by flats.

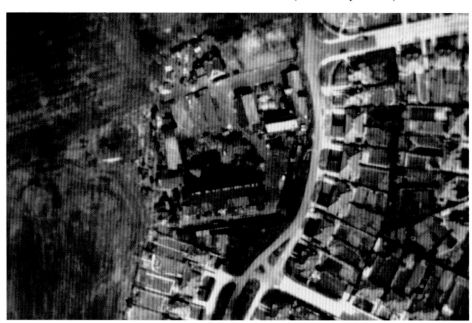

Kingsbury Station

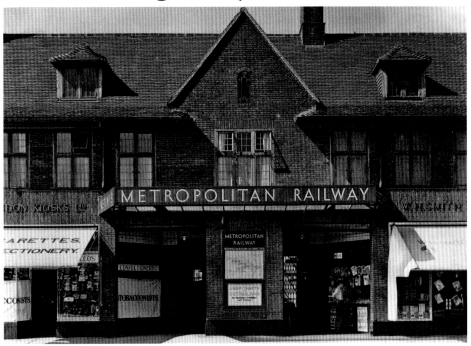

Kingsbury Station (1)

In the sixteenth century, John Lyon of Preston, who farmed much of the land here, left money for the repair of Kingsbury Road from Kingsbury Circle to the Edgware Road. Harrow School were still paying the highway board in the second half of the nineteenth century. The creation of Kingsbury Station as a new population centre was down to the extension and opening in December 1932 of the Metropolitan line and the route it had to take to reach Stanmore and avoid the land mass of Barn Hill. The publication of plans proposing new shops and ease of access to town made Kingsbury a desirable place in which to live from the late 1920s. The coming of the Metropolitan Railway into what had been an agricultural area caused a flurry of building and utterly changed the landscape. Above, the station in 1933. Below, Kingsbury Station Parade in 1933.

Kingsbury Pool

The open-air pool was opened in Roe Green Park on 13 May 1939. It cost £42,628 and included the usual plant, foot trough, paddling pool and a café. Note the elm trees in Bacon Lane to the rear. Proposals to provide better indoor facilities have in the past lacked adequate funding. It was closed in 1988 when the photograph below was taken, and was filled in 1990. The site was levelled and landscaped and two multi-purpose pitches were provided in 2006.

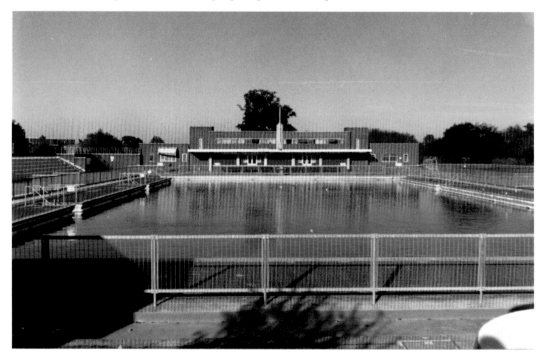

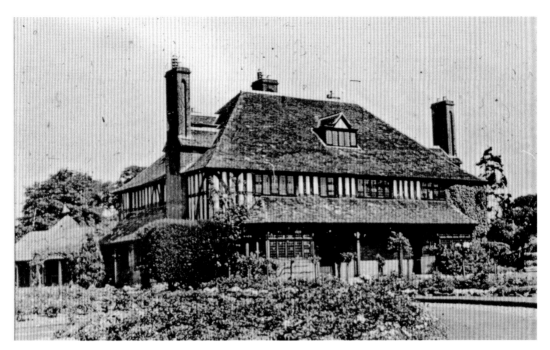

Kingsbury Manor

Originally 'The Cottage', the manor was built in 1899 for Lady Mary Caroline Blair, Duchess of Sutherland and her third husband Sir Albert Kaye Rollit, the MP for Islington. The architect was W. West Neve, who trained under R. Norman Shaw. Lady Blair had previously been the wife of Arthur Kindersley Blair, who was killed in a shooting incident in November 1883, and George Granville William Leveson-Gower (1828-92), the third Duke of Sutherland, whom she had married in March 1889. She is pictured at her third wedding in November 1896. Lady Blair is said to haunt Carbisdale Youth Hostel, which she commissioned. George Cloke acquired the premises in 1929 and renamed it Kingsbury Manor. It is now owned by the council. The walled garden has been the base of the Barn Hill Conservation Group since 1984, for which they have received various accolades, including the Green Pennant six years running. John Logie Baird rented the coach house and received the first television signals from Berlin here in 1929 and the first combined sound and sight transmission in March 1930.

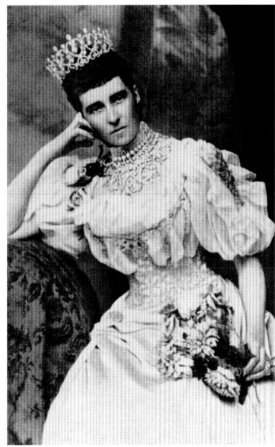

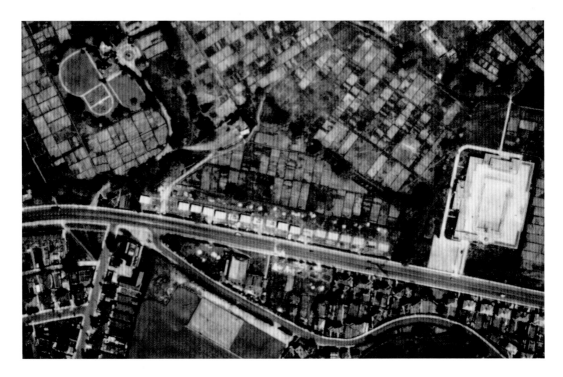

Kingsbury Road (I)

Aerial views show Kingsbury Road in May 1946 – above from Kingsbury Pool to Kingsbury Manor (top left), and below centred on Valley Farm. Note the street shelters and the use of Roe Green Park for allotments and prefab housing. Once private polo grounds, Roe Green Park was acquired by Wembley Council for public use in 1935 and 1938. Valley Farm was set up by Richard Heming of Hillingdon in 1848. The farmlands, including land on the south side of Kingsbury Road, were sold to the developer, George Cloke, in 1930; the farmhouse survived until after the war.

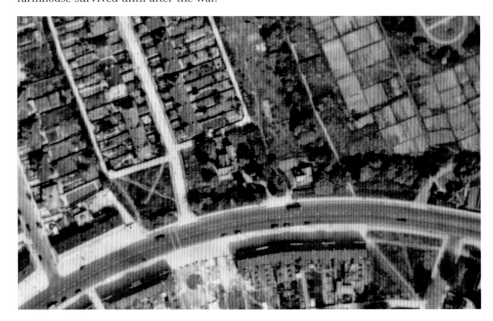

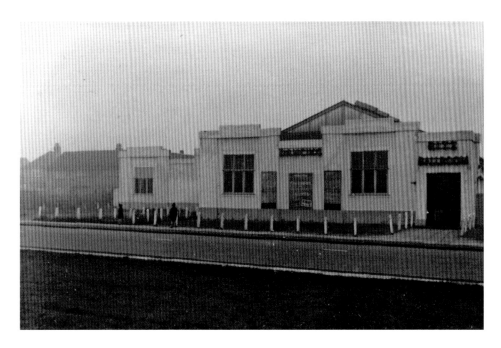

Ritz Ballroom

Opposite Roe Green Park, on the south side of Kingsbury Road, stands Westcroft Court, a block of flats built in 1964 on the site of the Ritz Ballroom. It was built as a clubhouse in 1930 and was soon the Victoria Dance Hall, named after the Victoria Cross, which had been won by its proprietor Jimmy Upton in 1915. By the 1950s it had become the Ritz Ballroom and in its day it was a very popular dance venue. It closed in the early 1960s.

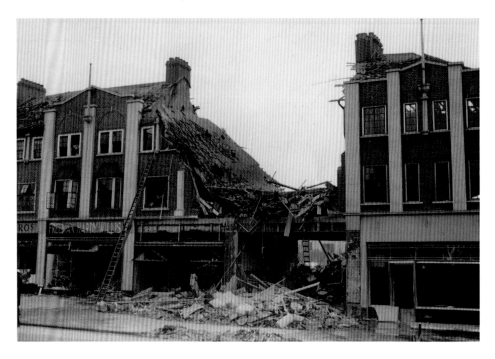

The Shopping Parade

443-9 Kingsbury Road was built in 1935-7 by George Cloke. On the night of 25 September 1940 it was hit by a German parachute mine. Four people were killed in the incident. It was rebuilt after the war in matching style, as shown below. There is still a shoe shop at no. 443. The Woolworths store at nos 451-3 closed in September 2009 after nearly seventy-five years.

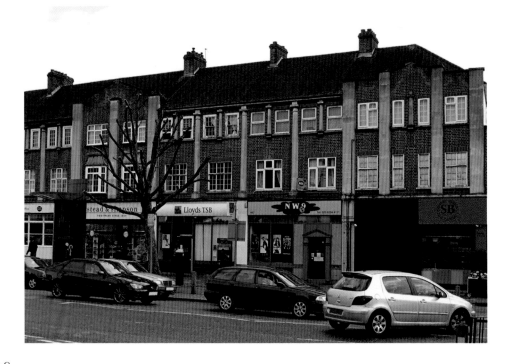

Kingsbury Station (II)

Above is a painting by C. F. Allbon of the approximate site of Kingsbury station in 1881. Right is a view of Kingsbury Road in 1910, near Gore Farm. It is the site of the former Odeon.

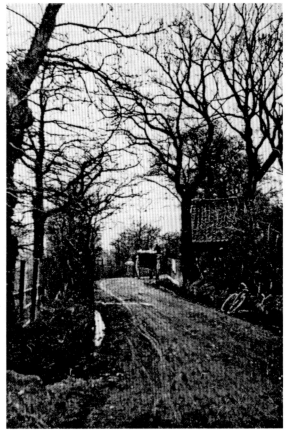

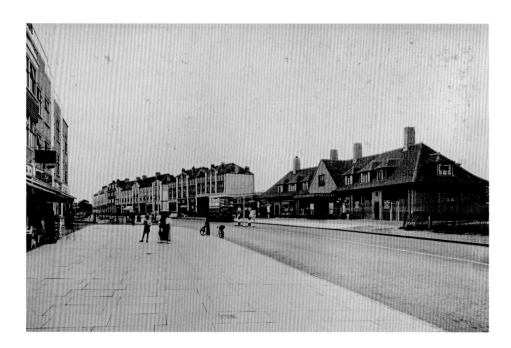

Kingsbury Station (III)

Kingsbury grew rapidly in the early 1930s. Many semi-detached houses on Mersham Drive and the south side of Crundale Avenue had already been completed; others were in development as part of the Valley Farm estate. Kingsbury station was opened in 1932 on a branch line of the Metropolitan Railway. This became part of the Bakerloo line in 1939 and changed to the Jubilee line in 1979. Some shops had appeared by 1931 and on 30 May 1934 the Kingsbury Odeon Cinema opened. The latter closed in September 1972 to be replaced by a Sainsbury's in 1979, which eventually became an Aldi supermarket and a health club.

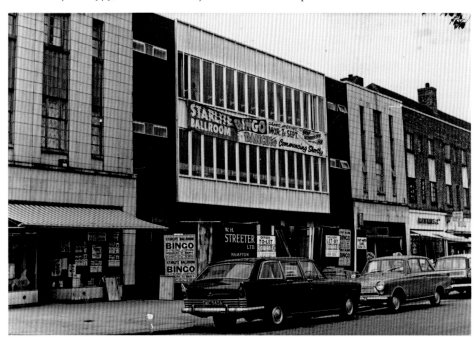

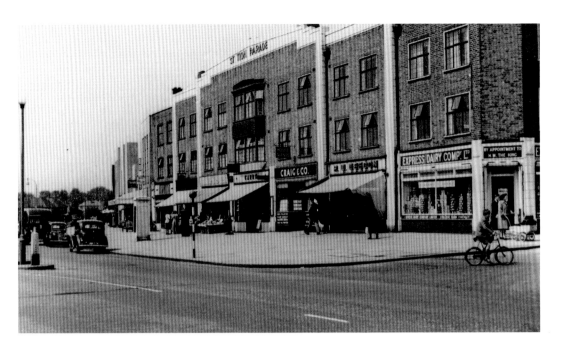

Station Parade

The shopping frontage then and now. It was originally built in 1931. The shops rapidly followed the houses that Keogh and Young were building, having received an Interim Development Permit to develop the Gore Farm estate from Honeypot Lane to Brampton Road in March 1929, thus anticipating the railway itself. The keyhole design of the front entrance was Keogh's trademark.

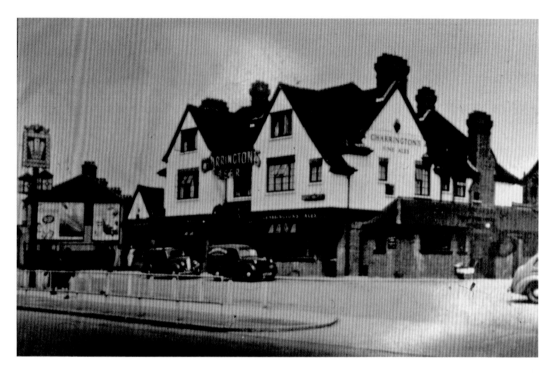

The Prince of Wales

The Prince of Wales public house was built by Charrington's Brewery in 1933 and a hall for social functions was added in 1936. The pub closed in 2005 and work in 2007/08 replaced it with a Tesco store and flats, the latter built by Nicholas King Homes.

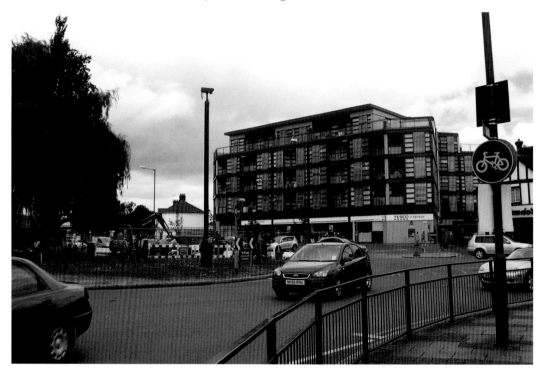

The Hyde

Kingsbury Road (II) / Holy Innocents (I)
The Hyde benefited from being part of
the Edgware Road, originally a Roman
road and one of the principal routes
in and out of London. The sixteenth-
century settlement expanded in Victorian
times. Kingsbury Road climbs the side of
Wakemans Hill and was excavated in 1922.
It was once much steeper and winding
than it is today. There were several
twists and turns in Kingsbury Road as it
descended to The Hyde, as seen here in
around 1900. The construction of Holy
Innocents Church in 1883-84 by William
Butterfield (1814-1900) – with the vicarage
to the rear – was a belated recognition that
the main area of settlement had moved
from Blackbird Hill to Kingsbury Green
and The Hyde.

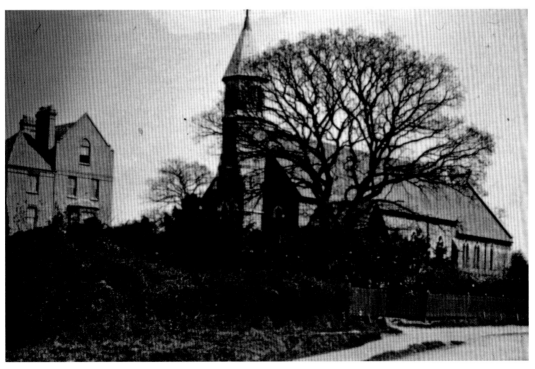

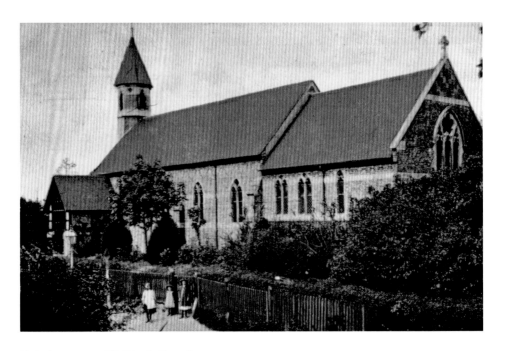

Holy Innocents (II) / Hyde Farmhouse

The new church was built despite local opposition. The vicarage behind the church was an austere three-storey building that survived until around 1958. Its site extended the playing fields of Oliver Goldsmith Primary School, which had opened in September 1937. Hyde Farmhouse dated from 1426 and stood well away from Kingsbury Road, where Crummock Gardens and Derwent Avenue now lie. The poet and author Oliver Goldsmith (1728-74) had lodgings at Hyde Farmhouse in 1771-4. A room at the back of the farm, in which Goldsmith wrote *She Stoops to Conquer*, was demolished just before 1898. The farmhouse was demolished in 1932.

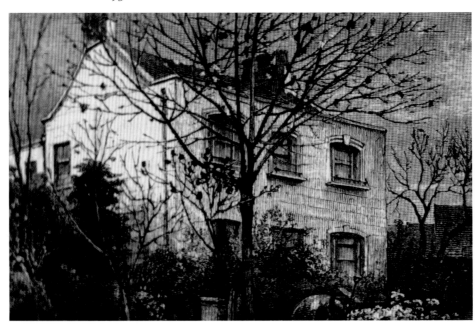

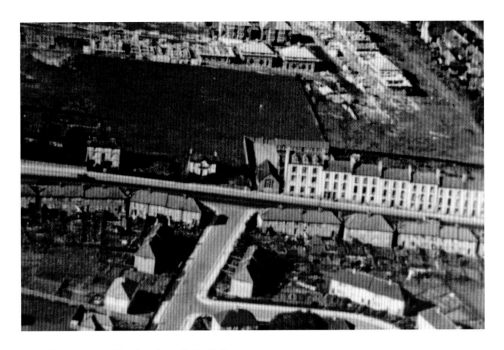

Kingsbury Council School amd Shell Cottage

The Kingsbury School Board built a board school in Kingsbury Road with room for 120 children in 1876; it was enlarged for 160 in 1902. The school occupied the ground floor at the end of a row of tenements that was referred to in 1934 as 'the ugliest thing in rural Middlesex'. It is shown here in 1930. After 1903 the school was called Kingsbury Council School. It was bombed in the last war and only the wall of the school playground remains. The school site is now occupied by flats.

Built in around 1752, Shell Cottage (below), at 44 Kingsbury Road, may be the oldest residential building left standing in Kingsbury today, although it has been drastically altered and modernised.

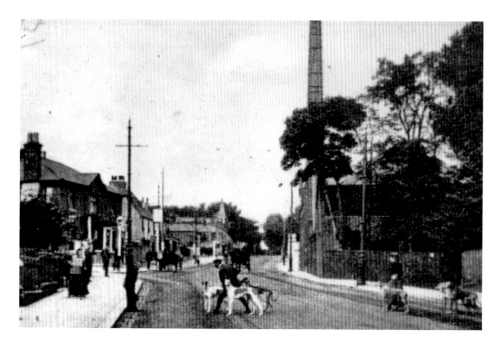

The Hyde Brewery / The Red Lion (I)

The old brewery used to stand with its tall brick chimney stack opposite Kingsbury Road. It was acquired from Arthur Crooke, the previous owner, by Mitchell & Aldous of Kilburn following its destruction by fire in March 1894. The brewery was rebuilt, as the postcard picture of 1912 shows, but it stood vacant for many years before its final demolition in the late 1950s. In 1851, there were four inns and a beer shop at The Hyde. These included the Red Lion, which had appeared by 1839 and is seen here on the left of the picture in around 1870, on the Edgware Road.

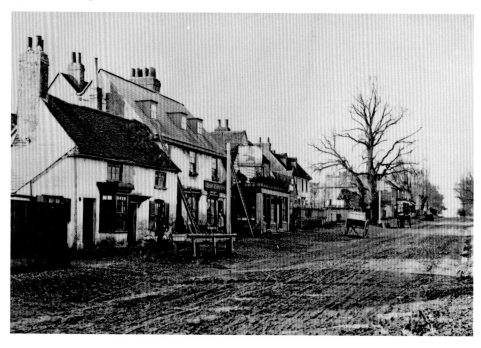

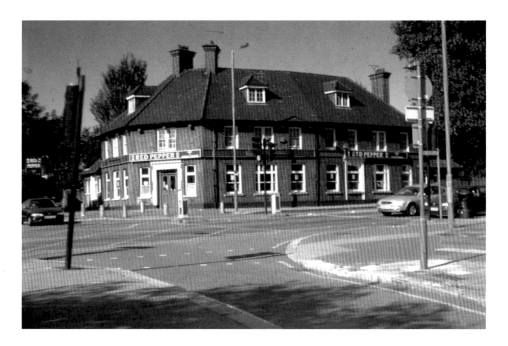

The Red Lion (II)

The Red Lion was rebuilt in around 1890 on the corner of Kingsbury Road, next to the original inn, and was then rebuilt again by the Cannon Brewery in 1930/31. This view of it was taken in 2008. In 1851 and until her death in 1866, the publican was Penelope Rodway. By 1871 it was Charles Cornwell. When the publican Henry Johnson died here in September 1927, he was succeeded by his son-in-law, Alfred Lincoln. The pub was demolished in February 2009 and has been replaced by a multi-storey care home.

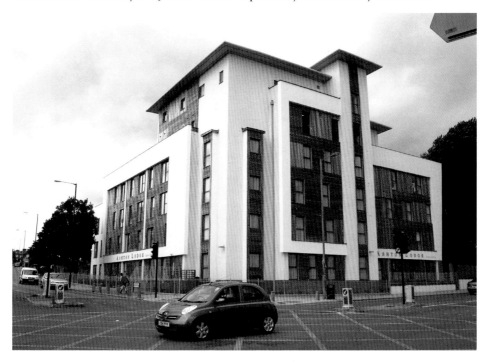

The Boot Beer House / Chad's Alley

In 1851, a bootmaker was running Boot Beer House, which stood to the north of the Red Lion. For many years it was kept by the Chad family, so the adjacent alley was known as Chad's Alley. The alley and nearby Bottle Alley (named after cottages constructed of bottle ends), were lined by narrow, overcrowded cottages, which were finally cleared to form an open space at the bottom of Crummock Gardens. In about 1915, publican George Skilliter left the Boot for the Magpie and Stump (shown below), where he stayed until 1928. He renamed it the New King's Arms, the old one having shut.

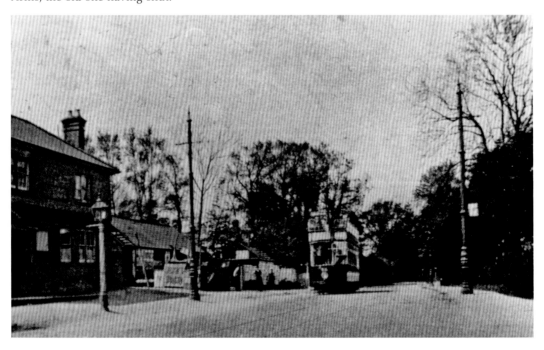

Springfield House

Springfield House was a Victorian villa. Occupied by the Vaughan family in 1871 and by General D. D. Bulger in 1901/2, it eventually became a maternity hospital, run by Dr Mary and Dr Nan Routledge. The premises were sold for redevelopment in about 1926, but survived the construction of houses in Forest Gate until at least the mid-1930s. Between the Magpie and Stump and Springfield House, a public pathway passed over stiles and Wakeman's Hill to reach Buck Lane.

Below is the King's Arms, once the Magpie and Stump (see left), as it is today.

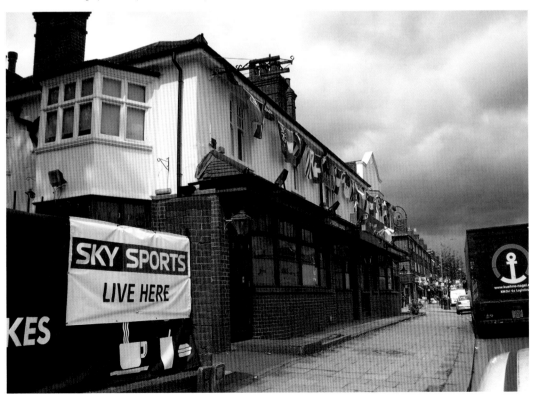

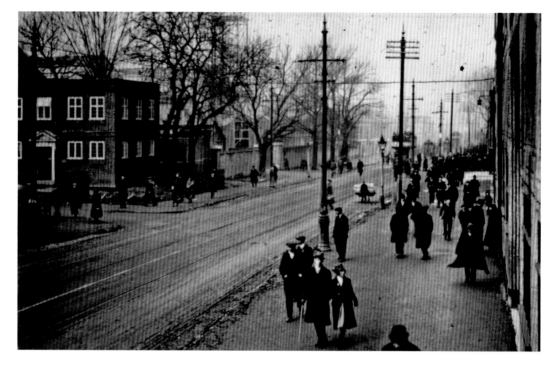

Airco (I)

By 1915-18, Kingsbury had become a centre of aircraft and munitions production. The major employer was the Aircraft Manufacturing Co., or Airco. The Airco offices were built in 1914 on the Edgware Road, shown here in 1917. Kingsbury County Grammar School took over the premises in 1925 before moving to Princes Avenue in July 1932. Kingsbury Secondary School took over the former offices before moving to new premises in 1952. The Edgware Road building became an annexe to Kilburn Polytechnic, pictured here in 1978, before becoming the Beis Yaacov School.

Roe Green

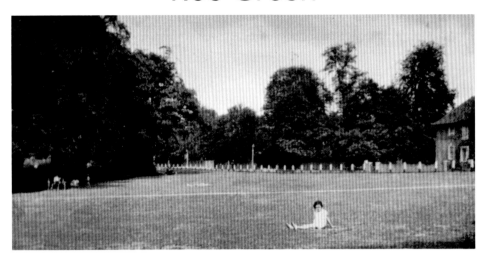

Fairfields House

The medieval village of Roe Green lay at the junction of Stag Lane, Hay Lane and Bacon Lane with the village green at the centre (above in 1936). Bacon Lane originally ran to Edgware from here. Just before 1750 the middle portion of the road fell into disuse, leaving two short stretches of road at each end. Buildings appeared in the fifteenth century on the land that Geoffrey Roe had owned in 1330. By the early eighteenth century, the southernmost house on the east side of the green was called Roe Green House. In 1839, its estate included meadowland on Wakeman's Hill. By 1890 the house was known as Fairfields and although rebuilt in 1896, it is the last remnant of old Roe Green. In July 1950, the front garden was assigned to the council as public open space and named after Alderman J. Caffrey. More recently, Fairfields House was acquired by the Brent, Kensington & Chelsea and Westminster Mental Health Trust. Substantial roof and side-extensions have been added as part of a scheme to provide twenty-six residential units.

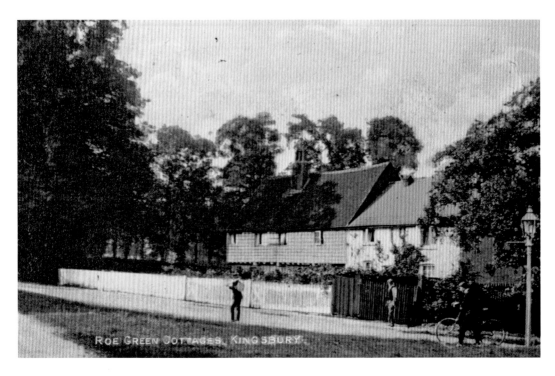

Park View Court

At the village centre, on the bend of Stag Lane opposite Hay Lane stood a row of sixteenth- and seventeenth-century timber-framed cottages (the property of Francis Stubbs in 1819-39). They were demolished in around 1950 and replaced by Park View Court.

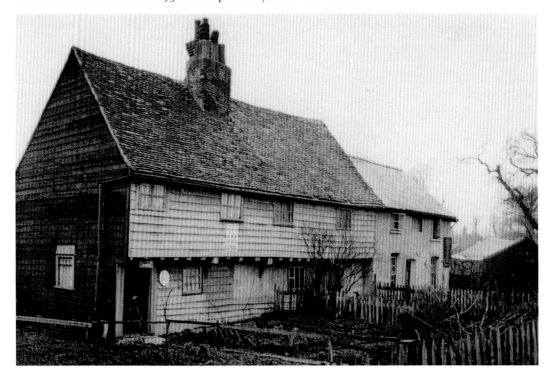

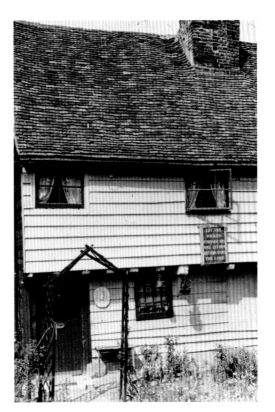

Boakes' Yard

Right is a detail of one of the cottages and below is what is currently on the site of Boakes' Yard. This was a contractor's coal yard and haulage business, long associated with the Boakes family. The business began with Jonathan Boakes (*d.* 1952) who was the local policeman and retired from the Force in 1919 after twenty-six years' service. He came to live at 1 Roe Green in 1917.

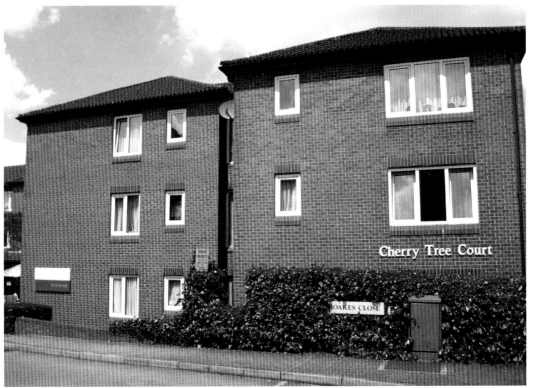

Roe Green Farm

The farm was built in around 1898 and was occupied by James Buchanan, a whisky distiller who kept his horses in the nearby fields. Buchanan came to live at Haydon House in 1892 and left the area in around 1936/7.

Below is a route 52 bus at Roe Green in around 1937. In the distance is part of the Elmwood estate, built by E. G. Trobridge in 1922. With the exception of 345-351 Stag Lane, the cottages were demolished after 1 and 3 Hay Lane burned down on Guy Fawkes' Night 1964. They were rebuilt as Kenwood Court in 1967-8.

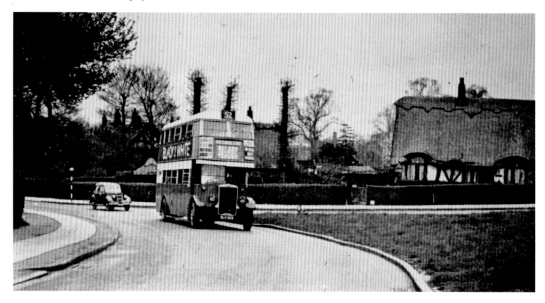

Haydon House

The Roe Green estate was centred around a fourteenth-century house where Haydon Close now lies; it was often leased out. The house was marked on a map of 1597 as Wroe tenement and was called Roes as late as 1896, although in 1887 it had also appeared as Haydon House. E. G. Trobridge rented it from 1915-22 and Captain de Normanville followed in the 1920s and '30s. Permission to build Haydon Close was granted in January 1938 and the house was demolished between 1937 and 1947.

Below is Hay Lane in the early 1930s. Originally it was part of Hayland, the estate owned by the de la Haye family, vassals of the earls of Lincoln, who held land in Kingsbury in the thirteenth century.

KINGSBURY POLO CLUB.

Colours—Red and white.
Started in 1896. Joined the Association in 1898.
Captain—A. S. Howes, 48 Porchester Terrace, W.
Telephone No. Padd. 7244
Secretary—W. F. Robinson, Manor Farm, The
 Hyde, Kingsbury, N.W.
Telephone No. 545 North.
Grounds—One full sized at Roe Green, Kingsbury.
Nearest Railway Stations—Hendon Station, Mid-
 land, 1½ miles. Willesden Green Station,
 Metropolitan, 3 miles.
Electric Trams from both Stations to Grounds.
Nearest Stabling Accommodation—On the Ground.
Season—From April to September.
Ground open for play to Members on Tuesdays,
 Thursdays (occasionally) and Saturdays.
Annual Tournaments 1914—Tattersall Cup, May
 18th. Winans Cup, June 22nd.
Number of Members—76 ; Playing, 20 ; Hon., 56.
Annual Subscription—Playing, £10 ; Hon., £1 1s.
Tournaments won—1909, The County Cup.
Handicap Committee—Mr. E. Covell, Mr. A. G.
 Howes, Mr. G. Sechiari.

Kingsbury Polo Club / Highfort Court

The club was started in 1896 and had some formidable players, such as the Duke of Westminster and the Spanish Conde de la Maza, who both played at international level. The grounds covered what is now the high school annexe and Roe Green Village. The club had sixty-three members in 1914.

In developing Highfort Court at the summit of Wakemans Hill, E. G. Trobridge found that the lack of housing subsidies meant that brick was cheaper than timber. His designs of 1935-7 reflect 'English architecture through the ages' using cement render and stone with turrets and arrow slits. The rest of the summit estate, by Aldous & Edwards, was more conventional.

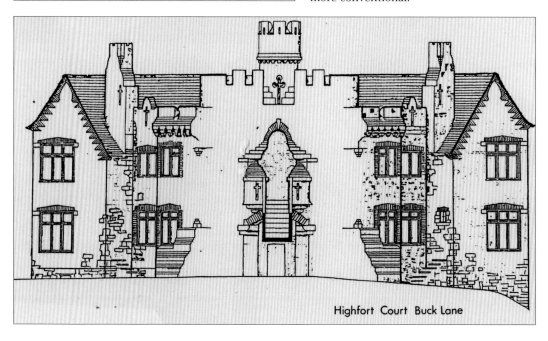

Highfort Court Buck Lane

Grove Park

Grove Park Mansion (I) / Grove Park School (I)

Grove Farm originated in land held by the Grove family of either Stanmore or Edgware in the early fourteenth century, and it remained with them until the 1470s. In the late eighteenth/early nineteenth century, an 'Adam' style mansion was built fronting the medieval farm buildings (pictured below prior to 1914). When Thomas John Bolton, the owner of Grove Park, died in June 1873, a firm of agents, Walton & Lee, was put in charge of its disposal, but Michael Walton acquired it for himself. He died in January 1892, leaving the property to his son. In 1915 William Walton began selling off the Grove Park estate to Airco and in 1916 the mansion house was sold to provide extra office space. The grounds provided space for an airfield as well as industrial expansion. With the threat that landing aircraft would shake loose the Grecian urns, they were moved from the roof in around 1916. On the right is the ice-cream man visiting Grove Park School in the 1920s.

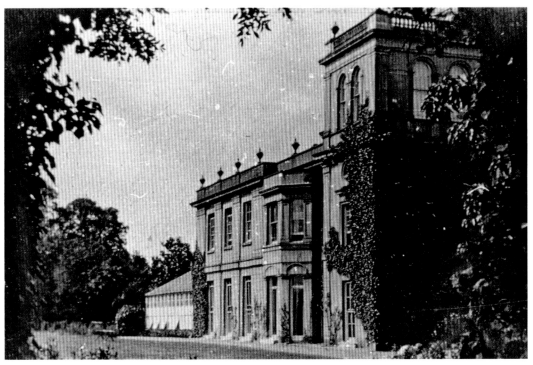

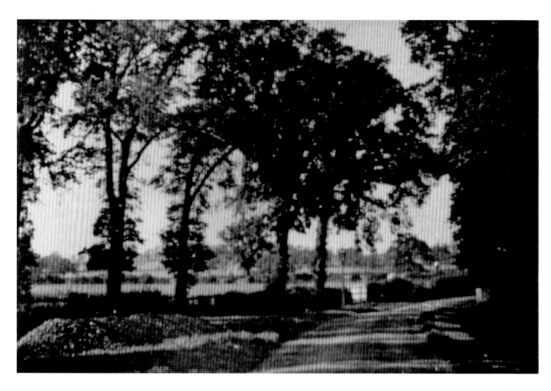

Stag Lane (I)
Above in around 1900 and below in 2010. This is the site of Roe Green Garden Village.

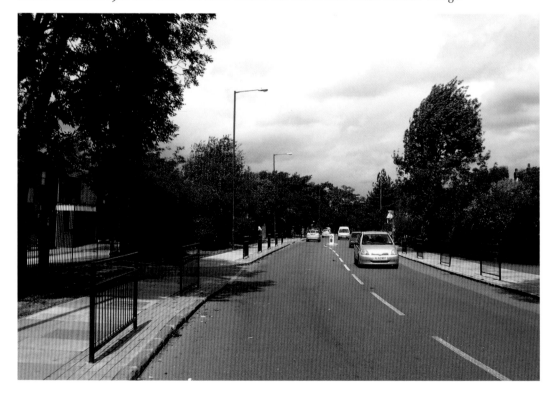

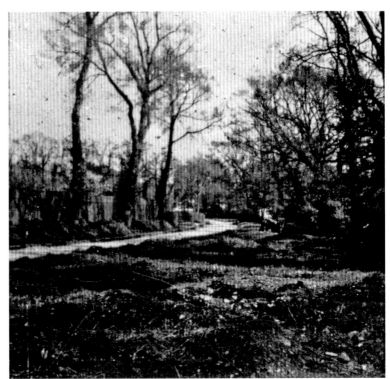

Stag Lane (II)
Looking south
to Roe Green in
around 1900 and
in 2010.

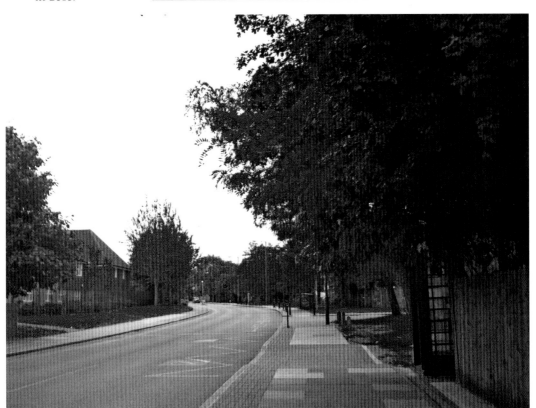

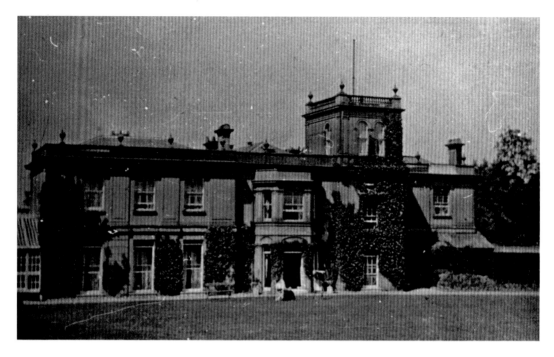

Grove Park Mansion (II)

The guest bedroom on the first floor with the bay window was where Lord Frederick Sleigh Roberts wrote a book on his forty-one years of military experience in India. Lord Roberts of Kandahar (1832-1914) was Commander-in-Chief of the British Army, to whom he was affectionately known as 'Bobs'. He stayed at Grove Park Mansion from 1893-95. Below is the view north from the east-facing front lawn of Grove Park in 1900. It overlooks what is now the Capitol Park industrial estate, and what was once 'Oriental City'.

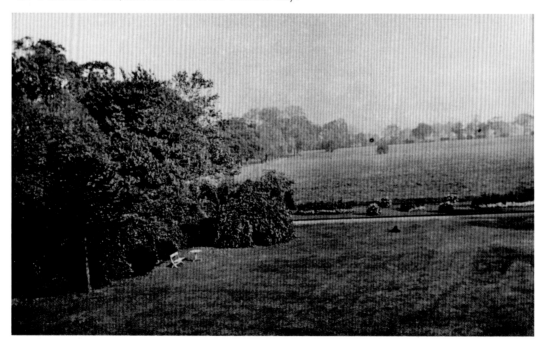

Grove Park Mansion (III) / Grove Park School (II)

Right, a gymkhana in the grounds of Grove Park in around 1900. In 1924, after the demise of Airco, Vivian Sharp acquired Grove Park and some six acres for £3,300. Here he opened a boys' preparatory school that accommodated some fifty boys each year until August 1939. A typical schoolroom is shown below. The school eventually moved to Crowborough, where it remained until 1964. Grove Park House itself was let for furniture storage until it was sold to Wembley Council, who demolished it in around 1947.

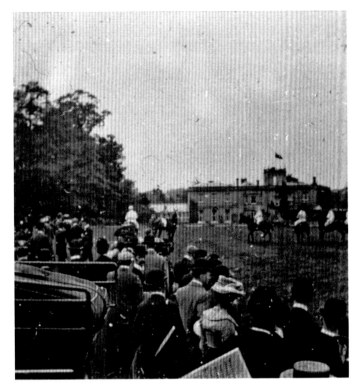

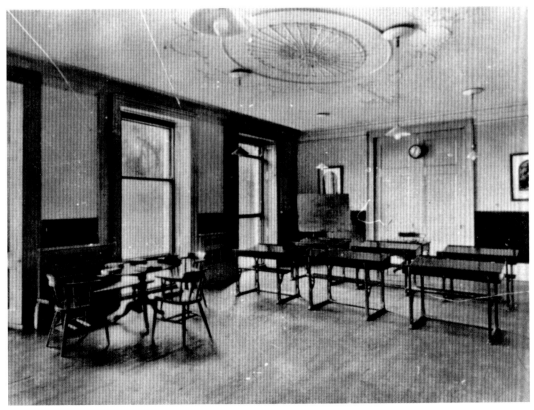

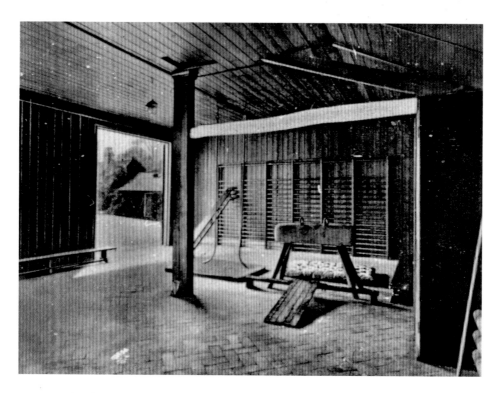

Grove Park School (III)

The gym and pool in the 1920s. The old converted farm outbuildings and swimming pool pictured here were demolished for the present-day schools. Only the lodge house on Stag Lane – built by Airco in around 1917 – survives. Hilbery Chaplin Ltd developed the Grove Park estate for housing in the early 1930s; houses in Grove Crescent were selling at between £700 and £750 in 1933. On the site of Grove Park there now stands Grove Park Special School, which was built for the physically handicapped in 1968.

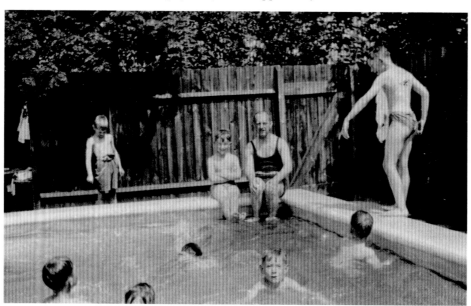

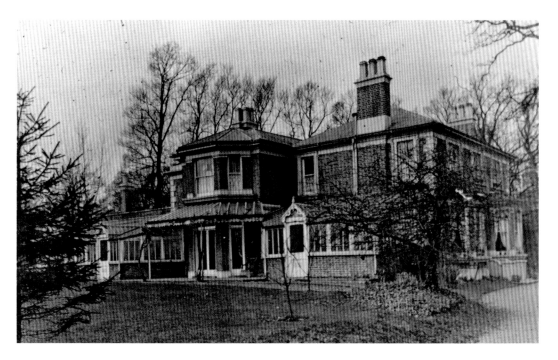

Elm Lea

Grove Park Mansion was located a third of a mile to the west of the Edgware Road, from where it had its main access along a tree-lined entrance drive. A lodge house and a well house stood at the entrance to this driveway and next to these was Elm Lea, an early Victorian property that survives today as Sunlight Electrical Wholesalers.

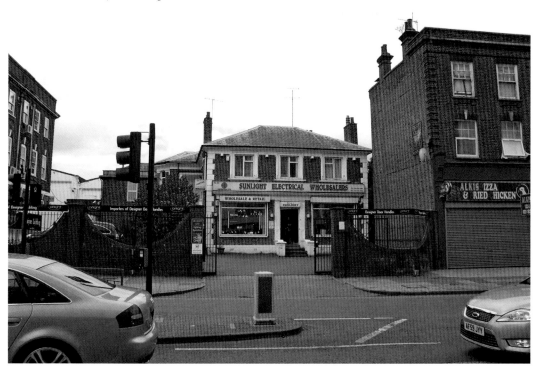

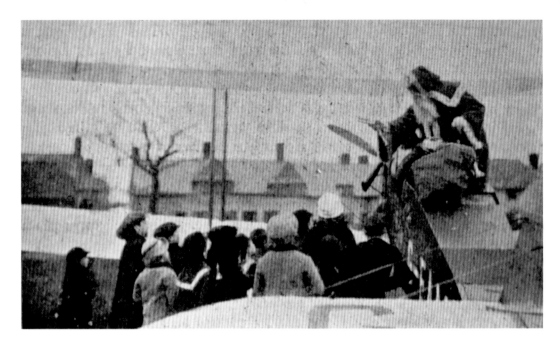

Christmas in Grove Park

In December 1919, Father Christmas brings presents for the children of Roe Green Village (courtesy of Airco). Below, Grove Park from the air in 1926. Stag Lane passes left-right across the bottom of the photograph. Note the realignment of Grove Park (the road) away from the grounds of the preparatory school, and the kink in the road that still exists. The northern crescent of trees (left) has been removed from the Grove Park airfield.

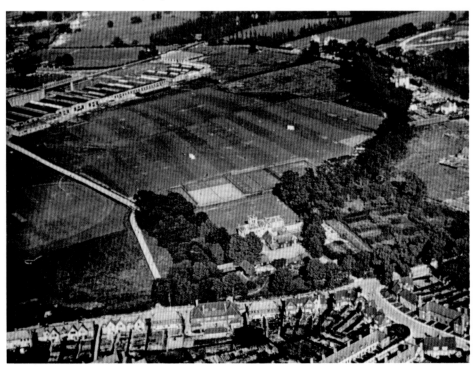

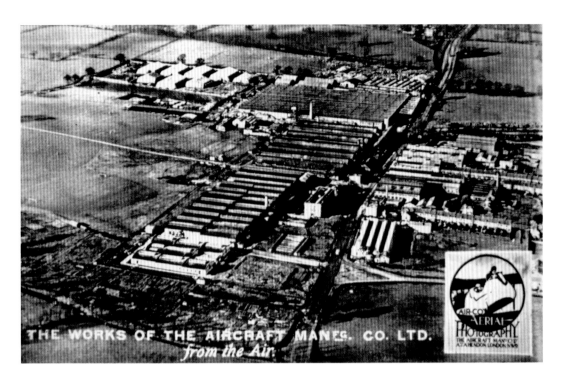

THE WORKS OF THE AIRCRAFT MAN^{FG.} CO. LTD.
from the Air.

Airco (II)

The Airco works seen from the air in around 1918-20. Note the Edgware Road running top to bottom and Grove Park from centre to top left. The award-winning housing development of 151 self-contained units, below, is by Pollard Thomas Edwards architects. Built in 2004-7 and called Airco Close, it would lie at the centre of the aerial photograph.

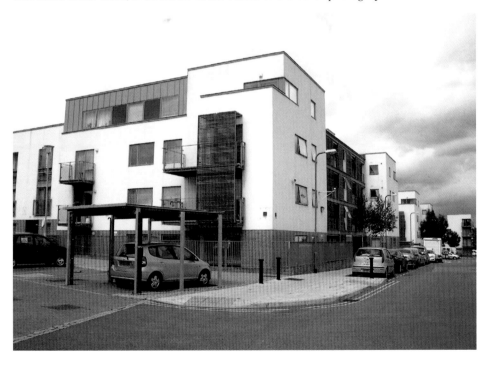

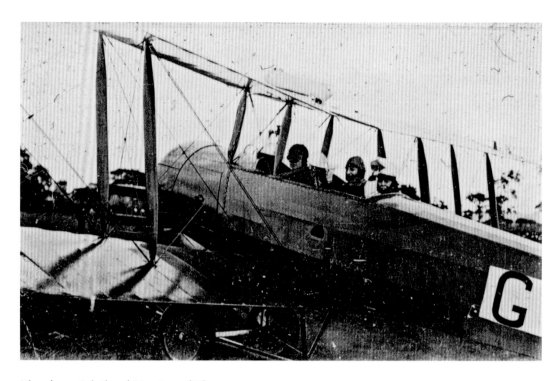

Kingsbury Aviation / Stag Lane (III)
An aircraft is flown in from Kingsbury Aviation at Grove Park in around 1918. Below, the westerly view from the tower of Grove Park Mansion looks at the site of Roe Green Garden Village in around 1900; Stag Lane crosses left-right.

Roe Green Garden Village

Roe Green Pond / The Hyde
The sudden and dramatic increase in employment in 1915-8 – necessary for increased output – brought problems of living accommodation and public transport to what had hitherto been a relatively isolated country area. In 1916, the Office of Works commissioned its principal architect, Sir Frank Baines CBE MVO (1877-1933) to design an estate of cottages for the aircraft workers. This was done along 'garden village' lines at Roe Green. Right is the pond in around 1900; this site is near 8-10 Goldsmith Lane. Stag Lane crosses left-right. Below, traffic chaos in The Hyde in 1917, caused by people travelling to and from work.

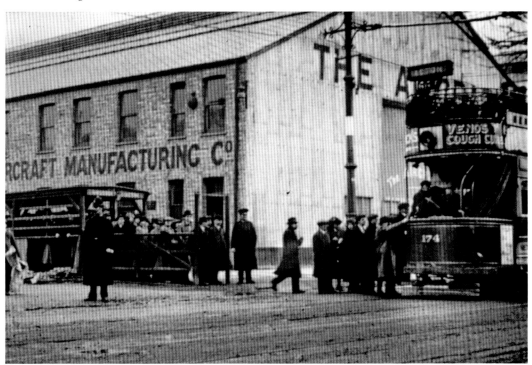

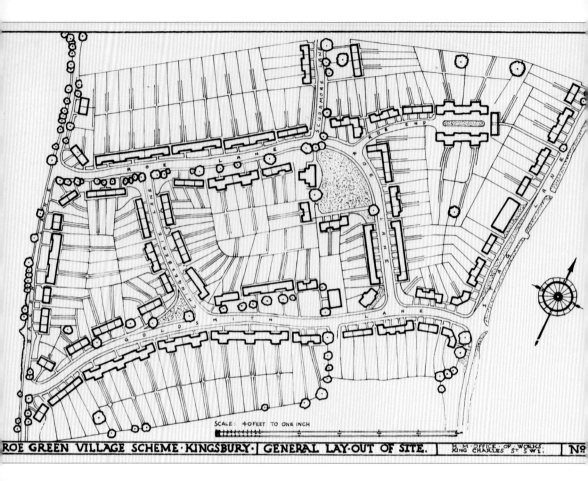

Village Plan, 1916

This plan has been redrawn by the author, based on one originally attached to house deeds.

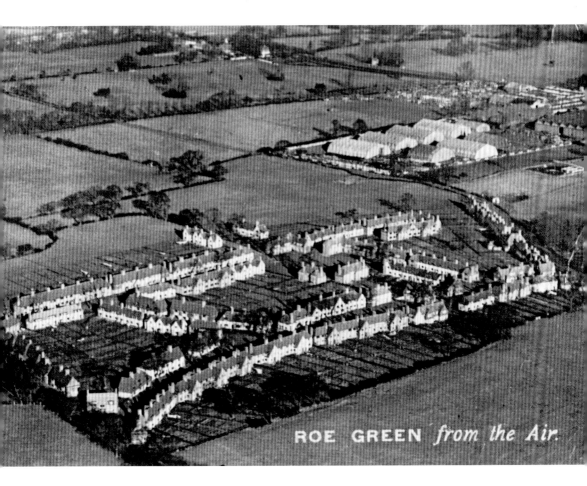

ROE GREEN *from the Air.*

The Village in 1920
An aerial view. Once Roe Green Village was a village in the country; now all the fields have been built on. Bacon Lane and Goldsmith Lane lie along the bottom of the photograph.

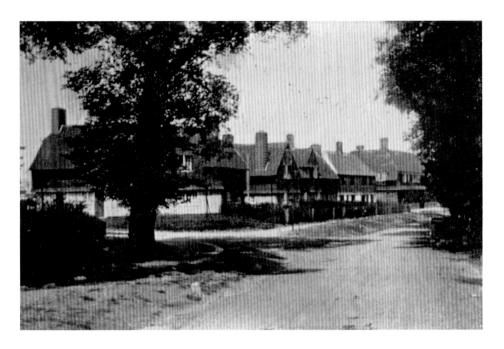

Stag Lane, 1920

Baines' concept of village design was refined by practice. Roe Green itself was based on his office's design for the Woolwich garden suburb (the Well Hall estate), which was built for the Royal Arsenal in 1915. The village green, inn, shops and doctor's house were all seen as essential ingredients. The shops in Stag Lane were formed in 1927, having been first let to the Willesden Co-operative Society. The first floor used for community purposes, including as a primary school while the Roe Green and Oliver Goldsmith Schools were being built. They opened in 1932 and 1937 respectively.

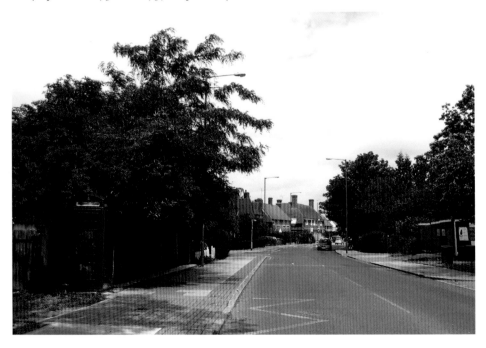

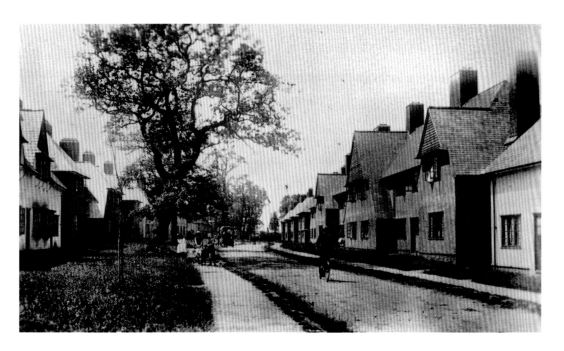

Roe Lane, 1921
Road making was to have been reduced to a minimum; costly and unnecessary kerbing would be omitted. Quick-growing hedges were provided for the back gardens, but those in front would be open to the road. Today, pavement parking and frontage hedgerows have greatly changed what the architect had in mind.

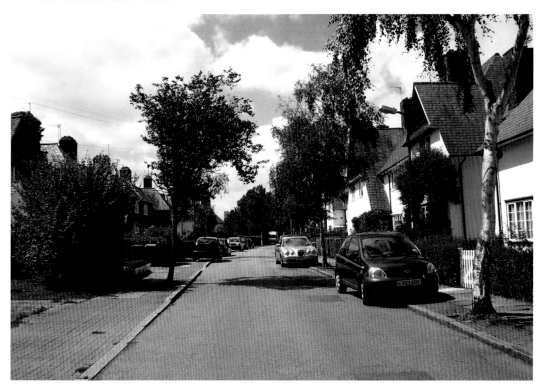

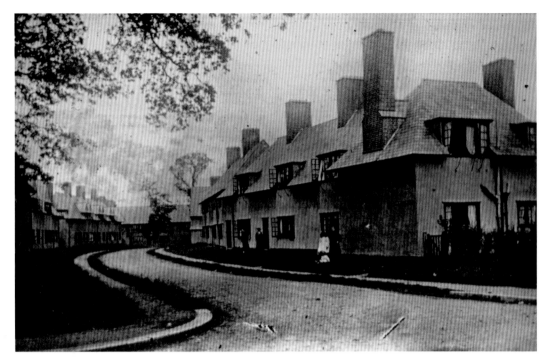

Shorts Croft, *c.* 1920

Since construction, there have been some notable changes to the estate, but on the whole these have been carefully monitored to maintain the village character. Below are sketches from the *Airco Rag* – the company's in-house magazine.

Goldsmith Lane (I)
The interior of one of the dwellings in 1919. Below, an image of Goldsmith Lane looking virtually complete, taken from the *Airco Rag*.

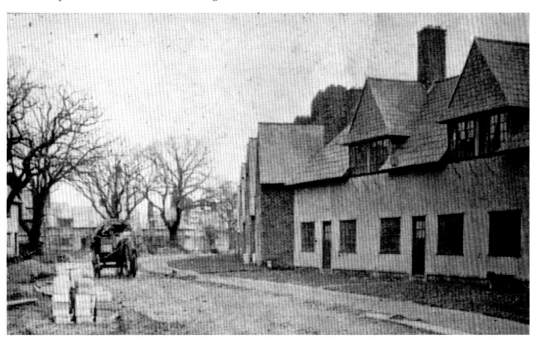

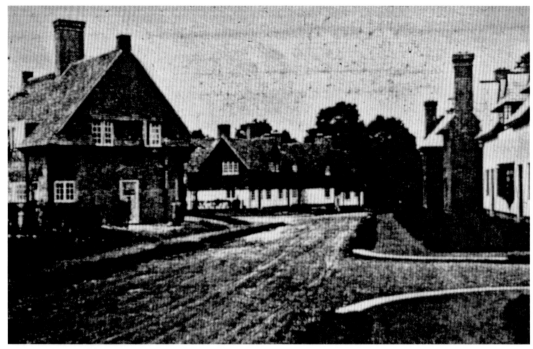

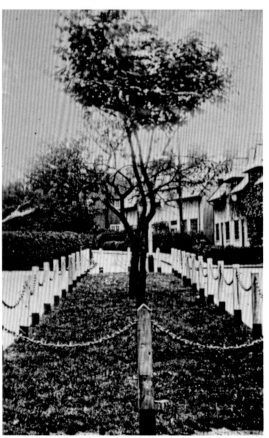

Goldsmith Lane (II)

An access point on the right was provided into the next field, should it prove necessary to extend the village. It did not prove necessary, but the access, along with the pub site and the redevelopment of the manager's house, did provide building sites for the construction of flats and houses in the 1960s.

Left is Roe End in 1930. The chain-link fence was taken away during wartime.

Roe End

Roe End in 1974 and in 2010. The landscaping was restored as part of European Architectural Heritage Year, 1975.

The Village Green

The green had been threatened with redevelopment in the 1960s but since 1974 (above) it has been landscaped and used for its original public purpose. Below, the fun and games of Village Day, held in midsummer, include stalls selling all manner of goods, and entertainments including tug-of-war.

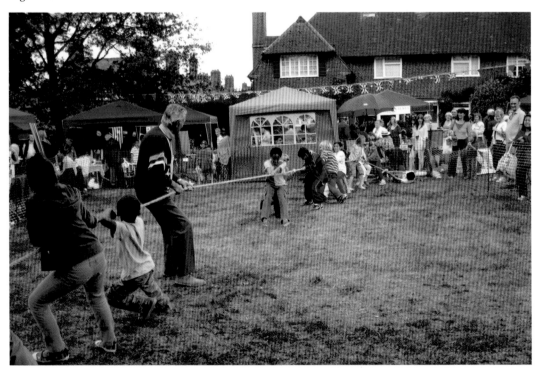

Queensbury

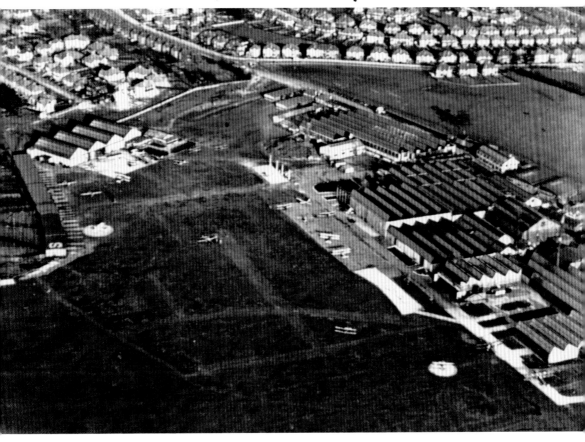

Stag Lane Aerodrome (I)

The creation of the suburb of Queensbury, population 50,000, was due to Percy Harold Edwards (1886-1937); it was probably the largest of those he planned. It was mainly through his efforts that Honeypot Lane was rebuilt as it is known today. Edwards inaugurated a newspaper competition to select a name for the new suburb and 'Queensbury' was chosen.

W. T. Warren and M. G. Smiles, the proprietors of the London and Provincial Aviation Co., ran a flying school at Stag Lane from 1916 until the end of the war. Previously, from 1914, their flying school had operated out of Hendon. From 1918/19, Warren and Smiles experimented with the manufacture of first furniture and then chocolate, neither with much success. In October 1920 they rented their premises to the new De Havilland Aircraft Company. Sir Geoffrey de Havilland (1882-1965), once the chief designer at Airco, brought with him a number of his colleagues. They set about completing two DH.18 aircraft that had been started at Airco. Early in 1921, with the help of financier Alan Butler, the De Havilland Aircraft Co. bought the airfield from William Warren for £20,000. Above is the aerodrome in 1933. Stag Lane runs along the top of the picture.

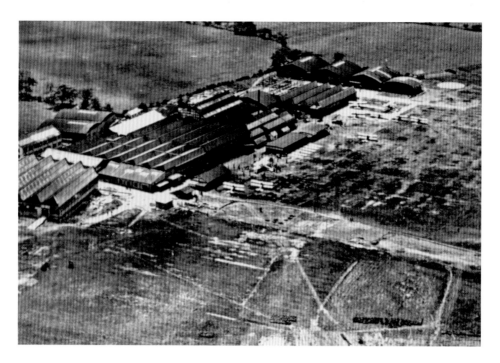

Stag Lane Aerodrome (II)

Above, looking towards Queensbury. Below, DH.60 Moths at Stag Lane. Both photographs are from the late 1920s. By 1923, De Havillands had built several Bessoneaux hangars and a permanent erecting shop. The workforce had also increased from fifty to 200. By 1926 more hangars had appeared and the workforce had risen to 1,000. The increase in business was mainly due to the Moth, whose prototype DH.60 was given its maiden flight on 22 February 1925. 'Moth' soon became a household word. In 1931 the Tiger Moth, on which many pilots trained during the Second World War, made its first flight from Stag Lane.

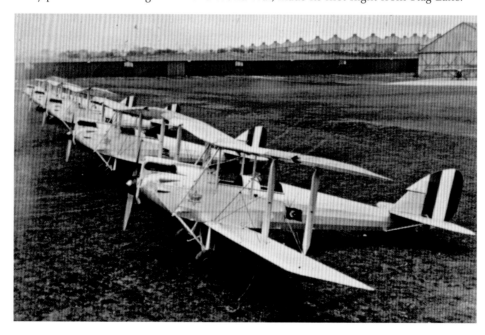

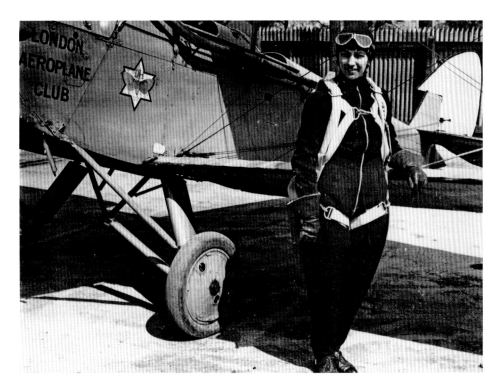

Stag Lane Aerodrome (III)

Above, Amy Johnson with a De Havilland biplane. Amy was born on 1 July 1903 and obtained a pilot's licence in July 1929. Less than a year later she became the first woman to fly solo from Britain to Australia. She often flew from Stag Lane Aerodrome. She was killed on 5 January 1941 when her plane came down in the Thames estuary. Below, the aerodrome in 1926.

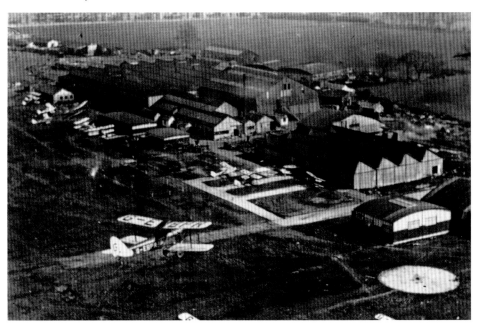

Stag Lane Aerodrome (IV)

The De Havilland team. Left to right: Broad, St Barbe, Hurle, Walker, Butler, Maj. Halford, De Havilland. Below, the aerodrome in 1928. At first De Havilland offered air-taxi services and offered repair, design and construction services. Sir Alan Cobham, who became famous for his pre-war air circuses and post-war flight refuelling, ran the taxi services from Stag Lane with a dozen converted DH bombers. Customers included newspaper photographers, salvage companies, and people on jaunts.

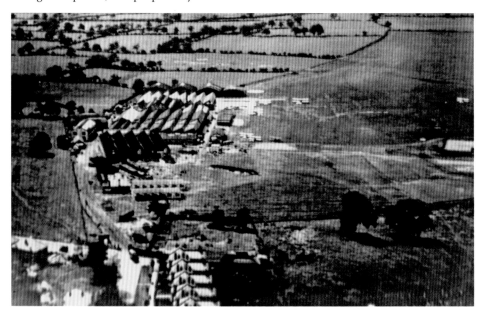

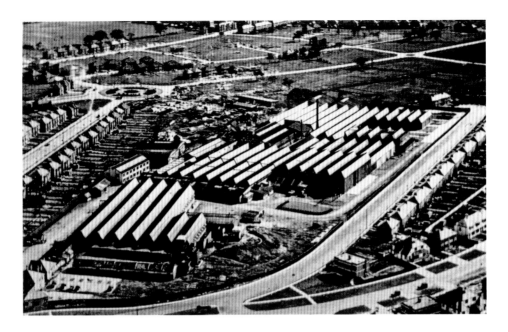

Stag Lane Aerodrome (V)

Stag Lane Aerodrome and factory, with Beverley Drive under construction, in 1935. Developments led De Havilland to move to Hatfield, and in January 1934 the aerodrome officially closed. The engine division remained, but the fields were sold to Hilbery Chaplin Ltd for housing. De Havilland made the last flight out of Stag Lane on 28 July 1934. In 1960 the engine division was sold to the Hawker Siddeley Group, who stayed until 1969. The factories that had survived the 1930s finally succumbed to redevelopment by the Metropolitan Housing Trust in 1995-6, who included commemorative public art (below). Laing Homes developed the Banks Automated Clearing Service premises in 2005-7, thus removing the last factory unit on the De Havilland site.

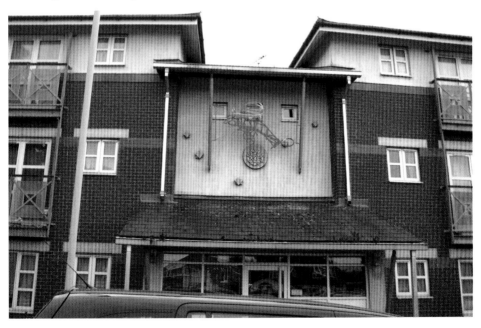

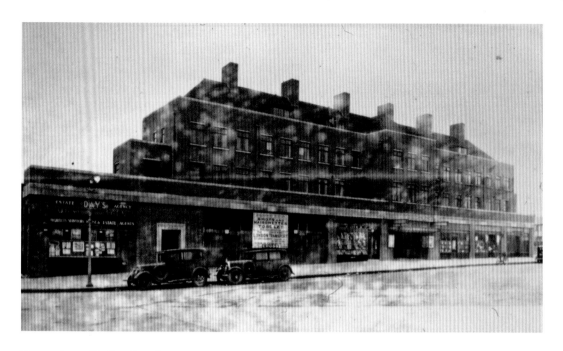

Queensbury Station Parade

Above, in 1935; below, a year earlier. When the Metropolitan Railway was opened to Stanmore on 10 December 1932, the location of Queensbury Station was still undecided. The sale of the land by All Souls College stipulated four stations, but the station proposed on Camrose Avenue to serve Queensbury Circle posed problems of construction. There was a better site at Beverley Drive. Here a station was underway by John Laing in August 1934 and was complete by 1937. A temporary halt had opened on 16 December 1934.

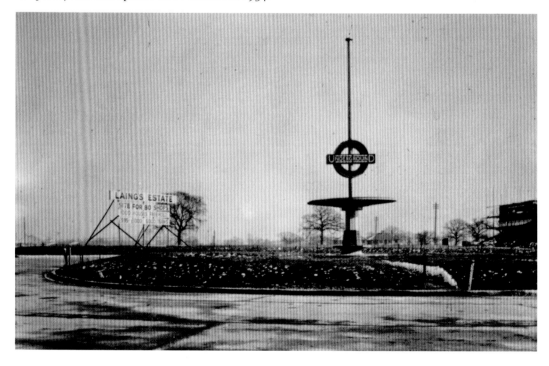

Eton Grove Open Space / Kingsbury County Grammar School

The open space above was acquired by the council in 1934/5 and laid out in 1937. It incorporated the old route of Bacon Lane, which crossed the park on its way to Sherborne Gardens, the former Flying Eagle, and Camrose Avenue. The downland characteristics of the landscape gave rise to the name – Hungry Downs. New homes meant new schools. Kingsbury County Grammar School had new premises in Princes Avenue in July 1932 (below). Tyler's Croft Secondary School in Bacon Lane was completed and opened in 1952. The two schools became one – Kingsbury High School – with the reorganisation of secondary education in 1967.

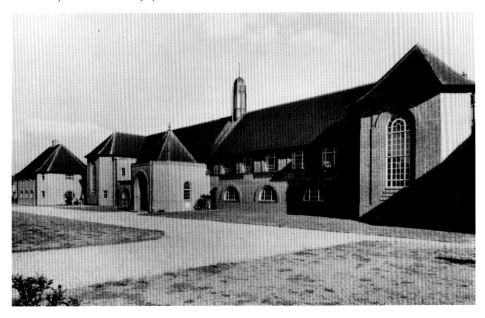

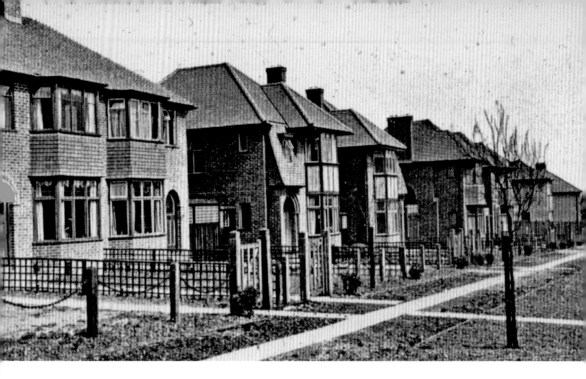

Beverley Drive / Melrose Gardens

Laing's Queensbury estate offered semi-detached houses at £670-£955 and detached houses at £750-£1,160: 'Hedges are planted near the front garden and wherever possible, greens and shrubberies are laid out, so that when completed Queensbury should present the aspect of a Park.' Spread over Hungry Downs, between two stations, it promised to be the 'queen' of North West London's many suburbs.

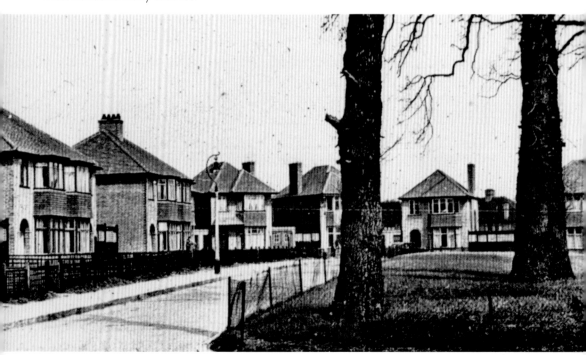

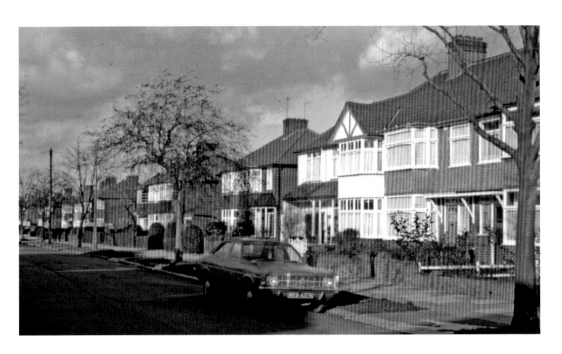

North Way / Mollison Way

House-building in Winchester Avenue and Eton Grove was the work of A. F. Davis, who acquired approval in 1929. Further east, much of Byron Avenue and Fairway Avenue was built for Hilbery Chaplin Ltd. In North Way (above) the change in building style mid-picture is quite distinct, the Laing Estate of 1934-7 marking the airfield boundary. The main airfield was sold to Hilbery Chaplin for housing in 1934, when Mollison Way (below) was under construction. It was named after Jim Mollison, the RAF pilot and famous civilian aviator who married Amy Johnson in 1932.

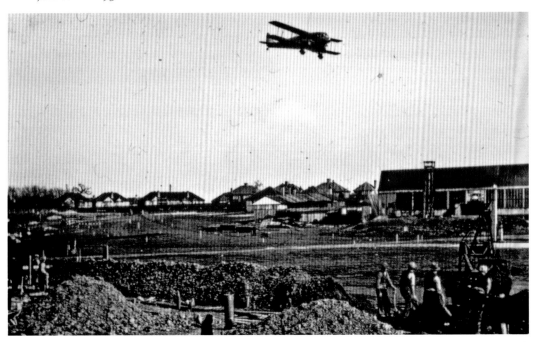

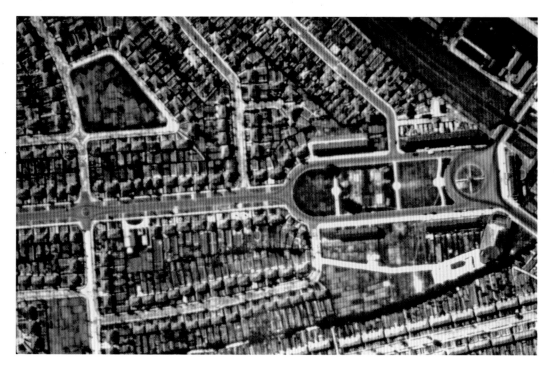

Queensbury, June 1947
Beverley Drive crosses left to right and Sherborne Gardens (one of Laing's greens) is located top left. Note the wartime street shelters and allotments and the site of All Saints' Church. The church was not built until the 1950s; it was consecrated in 1954.

Acknowledgements

I would like to extend my thanks to the following organisations and individuals who have each made my task that bit easier in presenting a wider picture of how Kingsbury has developed and changed (and continues to change) through time.

Aerofilms Ltd; Birlinn Ltd; Brent Archives; Brent Planning Service; British Aerospace Archives; Church Commissioners' Records; Ministry of Defence; Science Museum; Wembley History Society.

Andy Agate; Bob Chad; Roger Chatterton-Newman; Tony Dutton; Michael H. Goodall; Philip Grant; Susan Hewlett; Amina Hirani; Georges Jansoone; Victoria McDonagh; Debbie Nyman.

Oral History Interviews (August 1975-April 1984): Tom Boakes; Donald Bryant; Nancy Dancer; Doris Day; Thora Edwards; Nellie Harvey; Albert and Ethel Pidgeon; James Rance; Vivian Sharp; Tim Skilliter; Kathleen Trobridge; Win Upton.